№ 1

ERRANT BODIES_2006

SURFACE TENSION
SUPPLEMENT
№ 1

EDITED BY
KEN EHRLICH & BRANDON LABELLE

Surface Tension Supplement No. 1
EDITED BY KEN EHRLICH & BRANDON LABELLE

ISBN-10: 0-9772594-0-4
ISBN-13: 978-0-9772594-0-3

Errant Bodies Press
Copyright 2006

SERIES EDITORS: Ken Ehrlich & Brandon LaBelle
ASSOCIATE EDITORS: Octávio Camargo, Jennifer Gabrys, Michael Rakowitz, & Robin Wilson
COVER IMAGE: Cynthia Hooper
PRINTING: Gauvin Press

DESIGN: James W Moore & Penny Pehl

ERRANT BODIES
Grundtvigsvej 25a, 3th 1835 Wollam Street
1864 Copenhagen Los Angeles, CA 90065
Denmark USA
www.errantbodies.org

Errant Bodies publications are distributed by DAP, New York
www.artbook.com

TABLE OF CONTENTS

1 Ken Ehrlich & Brandon LaBelle
Introduction

4 Goto
Political Meanings: the Legacy of Interventionist Practice in Brazil

16 Aoife O'Brien
The Art Space Imperative—A Recent Reading

20 Robin Wilson
Blue Sky Thinking: A Utopia in Bristol

30 Claudine Isé
Vanishing Points: On the Exhibition at the Wexner Art Center, 2005

48 Brandon Lattu
Untitled: Slide Piece Edit

58 Ken Ehrlich
The Architectural Sign: Los Angeles in Buildings and Words

70 Kathy Battista
Let There Be Light: On Recent Light Art

78 SIMPARCH
Dirty Water Initiative

86 e-Xplo
Night Starring Columbus Ohio

108 Scott Berzofsky, Nicholas Petr & Nicholas Wisniewski
Notes for an Oppositional Urbanism in Baltimore

130 Jennifer Gabrys
Paper Mountains, Disposable Cities

140 Brandon LaBelle
Experiments in Reading *Experiments in Architecture*

INTRODUCTION

Surface Tension Supplements aim to provide a site for considering the growing contemporary international culture of artistic practices related to geographies, bodies and the issues generated by encounters between spaces and subjects. Planned as an on-going series, the Supplements will engage discourses around notions of site-based practice in art, architecture and performance through documentation of works, critical and explorative essays, and projects designed specifically for each book. It is our hope that these publications can serve as a meeting place, where the inherent diversity of contemporary cultural practice can find residence, with a view toward assessing, stimulating, and representing such diversity at its most public, social, and geographically-engaged moments.

Surface Tension Supplements are an extension of an earlier anthology, *Surface Tension: Problematics of Site (2003)*, which sought to take stock of the legacy of site-specific practice, recognizing the degrees in which it has generated cultural attitudes toward artistic work. As the notion of site has itself been re-defined, shifted and adjusted within contemporary artistic practice, questions of place and displacement, sites and non-sites, and location-based and interventionist practices have multiplied and their audience has expanded. Since the initial publication, we have found ourselves continually interested and re-invested in many of its themes, works, and ideas. Coupled with our own individual and collaborative artistic work involving performative acts of research undertaken in various cities over the last few years, the decision to reactivate the *Surface Tension* project seems appropriate and increasingly relevant. Our intention to continue the work initiated in the original anthology is also based in part on our ever-growing awareness of practices around the world that, however varied,

seem to cultivate an increased awareness of spatial and locational concerns. More and more cultural practitioners are questioning currents in urban conditions and policy, spatial constructions and architectural discourses, academic structures and institutional frameworks, forms of design and media ecologies, and these currents seem both to radically explode the assumptions around what it means to work site-specifically and truly extend this category into unknown and urgent territory.

Surface Tension Supplement No. 1 was initiated and developed according to the life and formation of an idiosyncratic network: each member of a newly formed editorial board contributed an article and in turn invited or selected a further contribution, thereby creating a series of conversations that appear on and off the page. In this first publication, issues of spatial practice are explored through critical reflections by Scott Berzofsky, Nicholas Petr, and Nicholas Wisniewski on their bus tours through Baltimore; Newton Goto on the history and culture of interventionist practice taking place in Brazil; and by Claudine Isé, curator of "Vanishing Point," an exhibition at the Wexner Center for the Arts in 2005, that questions the aesthetics of urban non-spaces through recent photography, sculpture, and film. These are complemented by reports by Robin Wilson on public art projects in Bristol developed by the working team of Sophie Warren and Jonathan Mosely; and Ken Ehrlich on the infrastructure of signage in Los Angeles as seen through the work of Brandon Lattu and Erik Göngrich, two artists working with cities and signs. In addition, documentation of public projects in Tijuana and Columbus, Ohio by the artist groups Simparch and e-Xplo are presented, which tease out the specificity of given projects and their attempts to adopt a critical yet generous relation to

community. These are complemented by Brandon LaBelle's photographic-textual review of the recent *Experiments in Architecture*; Jennifer Gabrys' first installment of *Refuse Reports*, digging into the issues surrounding waste as read through the geographic implications of Fresh Kills Landfill in New York; Kathy Battista's review of recent light art exhibitions; and Aoife O'Brien's critical reading of the legacy of the white cube and related criticism.

Site-specific work continues to operate through politicized modes, however subtle or overt, yet current versions of site-based practices reveal that the "political" is increasingly varied and complex. This has less to do with legislative issues and the theater of electoral politics—though we're certainly aware of the impact reactionary, progressive or even downright oppressive legislation can have on bodies and cities—and more to do with changing notions of being "public." The technological displacement of geography, and the shifting nature of political and economic borders and cultural identities related to notions of place, have all contributed to both diffusion and specialization around conceptions of site. At a time when the line between what is public and what is private is increasingly unclear, site-based practices in art, architecture and performance delineate trajectories of hope and highlight spaces of tyranny. Perhaps developing a context for discourses around geographies illuminated by artistic research might initiate subtle reconsiderations of the places we inhabit each day, and their potential transmutation.

Ken Ehrlich and Brandon LaBelle

Political meanings (and circuits) of art:
Affection, critique, heterogeneity and self-management in between culture's productive weaves[1]

Projeto Camelô, by the pair spmb (Eduardo Aquino and Karen Shanski), 2001. 100 models of the houses of a "favela" in Rio de Janeiro. The pieces were offered to the 100 richest persons in Rio de Janeiro as an exchange proposal. The money collected would be used to build communitary gardens in two hills (where the favelas are located) of the city. No buyer showed interest and none were sold.

Goto

POLITICAL MEANINGS: THE LEGACY OF INTERVENTIONIST PRACTICE IN BRAZIL

Contexts

The shift of art production from the strictly specific field of its own language into the widened environment of cultural relations has already been announced as the passage of art from the aesthetic into the political field:

> (...) since what is done today tends to be closer to culture than to art, it is necessarily a political interference. For, if aesthetics grounds art, it is politics that grounds culture.[2]

However, some reductivist interpretations insist on trying to temporally bind contemporary political art down to protest art or engagement against dictatorships, dating it as a typical 1960s and 1970s Latin American repertoire.[3] In Brazil, this rhetoric predominated in the 1980s and 1990s, following the cultural fashion of "art for art's sake," or even the retaking of formalistic-leaning strategies, thus exalting art production uncommitted to its social environment. The "return to painting," the ascension of the art market as a reference for art production, the growing social status of curators in detriment to the artists, the State retreat from direct responsibility in the definition of political cultures and a multiplication of art events linked to corporate cultural marketing (most companies making use of Tax Relief laws) are unfoldings of this tendency that began in the 1980s. A large-scale return to the interests and rules of the art market and its traditional constitution and operational system took place, after years of radical artistic experimentations in the 1960s and 1970s. Synchronicities: the multiplication of the multinational companies' powers, widespread Neo-liberalism, global market and communication, the Thatcher era; privatizations at a hallucinating pace, which, in Brazil, were financed by its own government; the fall of the Berlin Wall, the undoing of the Soviet block, crises in Socialist theories and perspectives; individualism, yuppies.... It was a time when ideas such as "utopia is over" or even "there is no more political perspective for action, because we live in a fragmented social world..." were heard echoing around. Considering this historical

1. This text stems from a Visual Languages Master's Degree dissertation. Goto, Newton. Remix Corpobras. Rio de Janeiro: UFRJ, EBA, 2004.

2. Meireles, Cildo. "Insertations in ideological circuits." Aranha, Mário. *Malasrates* n 1 Magazine. Rio de Janeiro: 1975:15.

3. Other distinct attempts of historical, geographical and interpretative demarcations of the concept of political art are sometimes announced in reference to the Mexican Muralism of the 30s (Diego Riviera, Siqueira, Orozco); to New Deal Art, in the USA during the Roosevelt Era; and to Socialist Realism in Stalinist URSS. Following this political use of "art" as an aesthetic and ideological instrument of the State on a high level of cultural guiding (as in the Soviet experience), the more extreme instances of such bias took place in the political propaganda films by exponents such as Leni Riefenstahl; in Nazi Germany Albert Speer's architecture was another example.

analysis, one is able to understand the foundations of statements such as "political art is something from the 1970s" or "what defines art is the market": a whiff of opportunism and "Neo-liberal engagement" lingers in the air, and puts its roots down.

Beyond the recognition of the value of the subversive and confrontational poetics in the 1960s and 1970s, which were built simultaneously on language experimentalism, the fact is that the political meanings of art reveal other complex and diverse contexts. Such observation by the way was already known by many artists from that period, who were the first to theorize about it, together with many critics. In the same way that political concepts and practices are reinvented in the course of histories and geographies, so are political art ideas, coming to build different insertion strategies and contextual art practices within the social fabric: *the art of institutional critique, the artist/curator, the social and ecological engagement and the collective fluxes* are some of the possibilities of this concept.

Between political art and policies for the arts there lies an immense field of realities. The situation goes beyond the strictly thematic issue, without limiting itself to thinking the political as something linked to the relationship with government or a political party. Art inserts itself into governmental cultural policies as well as non-governmental projects. Art is used as an instrument of economic power and marketing. It can become private property as well as an object of social ostentation. Art can be the detonator of new social behavior. It can change the direction of public policies elaborated both by the State and private enterprises. It can state its own politics. In short, it is known that all art becomes political whenever it is sited into cultural relations, of which, consciously or unconsciously, it will always be part.

The political meanings of art can be many, and many are its questions and strategic implications: the critical signifiers of the place where the work is inscribed—the critical limits; technical reproducibility; insertion into daily life; the use of cultural codes in detriment to the exclusively artistic ones; transit of the artist and art through different ethos of a society—cultural mediation; the relationship between the artistic circuits and the art markets; art and behaviorial freedom; high and low cultures; the culture industry; questions in between art X culture, aesthetics X politics, form X content; questions engaging reality and simulacrum; the political and productive microclimates; the deceleration and importance of the reconstitution of collective memories; the "histories" of art; and the self-management of artistic production.

Politics also becomes an ability to fix different art circuits, whether the production of circulation spaces or flows managed by artists' collectives or the artwork built by creative participation. The most fundamental meaning of the term "political," as stated by Hannah

Arendt,[4] is the ability of the individual to dialogue with the collective, a dialogue based on the common interest and the common good. The self-managed spaces and flows can processionally resemble institutions' political culture programs: schedule of events, curatorial work, production of texts and graphic printed matter, debates, etc. However, artistic production strategies and critical contents of *self-dependent circuits*[5] are generally different from the traditional circuit: they affirm other artists, ideas and processes. Nevertheless, the transit of this art and of its agents could occur in both circuits, *traditional and self-dependent*.

Nowadays there are a significant number of these circuits in Brazil. It is a political intensification in the field of art, because the freedom and autonomy of actions are being acted out. And there is a certain unyoking of the formats, places, processes, deadlines, hierarchies and interests cultivated by the traditional institutional relationships. In Brazil, at the end of the 90s these *self-managed circuits* began to gain greater visibility within the artistic environment, coming to be usually named artist's collectives, *self-managed circuits* or cultural activism art. They were built in different places and with different motivations and historical conditions. Among these pioneers one can find Arquivo Bruscky (performing since the 1970s), Torreão (since 1993), *Arte de Portas Abertas* and *Interferências Urbanas, Galeria do Poste, Agora, Capacete , CEP 20.000* and *Almanaque, Museu do Botão* (since 1984),*Camelo and Linha Imaginária*. Later emerged Alpendre, *Atrocidades Maravilhosas* and *Zona Franca*. And from these, others followed.

Concepts

Different from conceiving this phenomena as a "widening of the circuit"—thus considering new emerging circuits as part of the same system of relations—this dynamic could be understood as a practice of *heterogeneous circuits*,[6] bringing them closer to Alain Badiou's thought: political heterogeneous strategies place themselves ahead of the status-quo, defining their own place and time, and processionally manifesting their singular characteristics through this relation. For the philosopher, the defense of heterogeneity becomes the main focus of resistance and political statement in contemporary culture. It is not enough to oppose a policy that was predominantly established by the Government or by the global market, accepting its timings, places and parameters. It becomes necessary to affirm the cultural singularities of social collectivity. This political sense imbricates in its own existence, as Pierre Bourdieu analyzes: "the symbolic systems, which a group produces and reproduces in the scope of a certain type of social relationships, reach their true meaning when related to the power relations that make them possible and sociologically necessary."[7]

4. Arendt, Hannah. A *Condição Humana*. São Paulo: Editora Forense/ Salamandra/ USP, 1981.

5. The concept of self-dependence is used by Werner Herzog as an alternative to the understanding of " independent cinema" production, as opposed to imagining this productive extent as something that is not linked to partnerships—independent. The moviemaker sees this action field as something that fundamentally depends on its own author to exist, partnership articulations included. Herzog, Werner. *Coração Selvagem*. Paulo Camargo and Carlos Augusto Brandão (interview and text). *Gazeta do Povo*. 31 Jan 2005. Curitiba: Caderno G.

6. The term heterogeneous circuit is inspired by Alain Badiou's concept of heterogeneous politics. Its foundations are a statement of singularity and of a heterogeneous logic. I adapted this concept to artistic activity, having as references the notes I took from Alain Badiou's lecture in a conference delivered at the Colóquio Interdisciplinar Resistências, Cine Odeon, Rio de Janeiro, 2002.

7. Bourdieu, Pierre. "O mercado de Bens Simbólicos."*A Economia das Trocas Simbólicas*. São Paulo: Perspectiva, 1992: 176.

The concepts of multitude, biopolitical entrepreneur, value and affection formulated by Toni Negri[8] can add to the idea of *heterogeneous circuits*. Nowadays, the concept of multitude is very different from the 20th century. The mass is not a mass of working people anymore, it cannot be encompassed by a social class discourse, it is not homogenously uninformed, or nearly illiterate. In addition, one does not live in a world wherein the economic elite presents itself as an exclusive cultural elite anymore. The multitude today has become more diversified and more educated; it is potentially able to propose policies and dynamics of its own within society. In *value and affection*, the affective relationships between people and groups are perceived as revolutionary possibilities for the building of productive meshes: they are transformation potentials; they are desire investments in the build up of a community between subjects.[9] And the post-modern *biopolitical entrepreneur* of whom Negri speaks is "someone who is able to articulate point by point the productive capacities of a social context," "a subject that organizes the reproduction conditions of life and society, and not only its *economics*." This productive entrepreneur is "in opposition to all capitalistic theories of the parasite entrepreneur."[10]

The "total entrepreneur who cares essentially for the construction of a productive mesh,"[11] is also similar to the concept of the *author producer* by Walter Benjamin, wherein it is clear how indispensable the rupture of the boundaries is between "the material and the intellectual productive forces."[12] According to Benjamin Buchloch, the Benjaminian *author producer* "must, above all, approach the modernist structure of isolated producers and try to convert the artist position of aesthetic goods supplier into an acting force of transformation of the existing ideological and cultural apparatuses."[13] Benjamin says that it is necessary "to orientate other producers in their productions, making a 'more perfect apparatus' available to them, measured by the ability to transform the 'readers or spectators' into 'collaborators'."[14]

The dilution of the limits between artist and public has also been formulated and practiced throughout the 1960s and 1970s, in tune with the basic libertarian tenet "every human is an artist."[15] Hélio Oiticica has also found that the artist should unfold himself into multiple fields of action: the artist territory of action has become an expanded field—physically and ideologically—and the artistic act could directly hit the collective production processes: "The great artist (…) could also take up the roles of the 'entrepreneur', the 'educator' and the 'propositionist', creating conditions for popular participation in these open propositions."[16] Critic and curator Frederico Morais has also converged with these ideas: "It is not a matter of taking art (a finished product) to the public, but taking the creation itself, amplifying, in this way, the range of art creators

8. Negri, Toni. *Exílio. Seguido de Valor e Afeto*. São Paulo: Iluminuras, 2001.

9. Ibid: 66.

10. Ibid: 35.

11. Ibid: 35.

12. Benjamin, Walter. "O autor como produtor." *Magia e Técnica, Arte e Política*. São Paulo: Brasiliense, 1984:129.

13. Buchloh, Benjamin. *Procedimentos alegóricos: apropriação e montagem na arte contemporânea*. Ferreira, Glória, Venancio Filho, Paulo (Org.) Revista Arte & Ensaios n°7. Rio de Janeiro: Editora UFRJ, 2000:190.

14. Idem note 12: 132.

15. Beuys, Joseph. In: De Duve, Thierry. *Kant depois de Duchamp*. Ferreira, Glória, Venancio Filho, Paulo (Org.). Revista Arte & Ensaios n 5. Rio de Janeiro: Editora UFRJ, 1998: 126.

16. Oiticica, Hélio. Vianna, Hermano. *Não quero que a vida me faça de otário!* In: Velho, Gilberto, Kuschnir, Karina. *Mediação, cultura e política*. Rio de Janeiro: Aeroplano, 2001: 41.

instead of art consumers. Art does not belong to the one that buys it, collects it and, at the limit, of who does it. Art is the citizen's common good."[17] The heterogeneous artistic circuits are producing not only art, but new artists as well.

These circuits are in dialogue with Hakim Bey's idea of *Temporary Autonomous Zone—TAZ—* (Zona Autônoma Temporária),[18] adding the ephemeral factor to revolutionary desire. Because one no longer wishes for a totalizing and everlasting revolution as it was defined in modern times. TAZ is a local action, a social way of insertion, brought about by specific necessities, propitiating experience, knowledge, transformation and memory to its participants. Having the possibility, therefore, of ending. And re-emerging in a new configuration.

The freedom action generated through the *heterogeneous circuits* could characterize an attitude of insubordination and cultural resistance to the "consecration monopoly" and to the market, as Pierre Bourdieu states.[19] The possibility of a more aggressive articulation of critical contents emerges from there.

Reflections generated in experiences that are explicitly political, dialogue with the *artistic circuits'* nuanced political meanings. Certain revolutionary identities of ex-militants from the armed struggle in Brazil have transformed themselves, migrating from a "macropolitics through the State" towards a perspective applied to daily life, based on sharing values and the affirmation of an "ethos" of the social body. Vera Silvia Magalhães, radical protagonist in this story, names this change in the political paradigm as a "micropolitics of affection."[20]

Micropolitcs of affection, productive biopolitics, heterogeneous politics, heterogeneous artistic circuits: Something of a common necessity in relation to life that trespasses art, philosophy and the politics of our time.

Strategies

Some tactics of these *artistic circuits* reoccur: the making available of its own physical spaces for the manifestation of art; circumscription of urban areas and other sites for performance and interventions; the occupation of institutional spaces with its own activities program—including curatorial work and collective management performed by artists; organization of meetings, debates and shows; support of the production of work; creation of different strategies for economic sustainability; elaboration and publication of critical texts, reports and records of actions in printed or electronic magazines; establishing exchange programs between artists; creation of documents and video archives. In short, these practices affirm a real perspective of social self-management of information and artistic productions.

17. Morais, Frederico. *Domingos da Criação.* Folder n 10 from the exhibition. Anos 70: Trajetórias. São Paulo: Itaú Cultural, 2001.

18. Bey, Hakim. *Taz—Zona Autônoma Temporária.* São Paulo: Conrad Editora do Brasil, 2001.

19. Bourdieu, Pierre. "O Mercado de bens Simbólicos." *A Economia das Trocas Simbólicas.* São Paulo: Perspectiva, 1992.

20. Sivia Magalhães, Vera. *Micropolítica do afeto.* Interviewed by Newton Goto. Revista remix Corpobras. Rio dejaniero: Remix Corpobras, Camelôoutdoor, 2004. text also published, parcially, in revista Global Brasil n 5. Rio de Janeiro: rede Universidade Nômade, 2005:22.

In Brazil, there are circuits that privilege the place as an intervention instigator, rooted in specific relationships with architecture, urbanism, geography and social cultural contexts. For instance, *Torreão* (Porto Alegre), *Galeria do Poste* (Niterói) and *Intervenções Urbanas* (Arte de Portas Abertas, Santa Tereza, Rio de Janeiro).[21] Others invest mainly in the *temporal happening*, creating programs that facilitate performances, actions, video screenings, slide shows, sound interventions, etc. Adjusting themselves even to different spaces, these happenings can take place periodically or even occur just once: CEP 20.000, *Zona Franca*, *Açúcar Invertido*, all in Rio de Janeiro, are amongst the most intense happenings of this kind.[22] There are circuits that propose actions with formative and didactic characteristics, even establishing collections, and making from the debates and from the transmission of information a political complement for the artistic activity and society. Among these, *Arquivo Bruscky* (Recife) and *Torreão* (Porto Alegre) generate actions with the widest cultural repercussion. *Capacete* should be highlighted, and so, while it existed, *Agora*, both in Rio de Janeiro; in addition, the *Centro de Contracultura* (São Paulo).[23] Other collectives constitute stable partnerships between their participants, forming artists' groups, proposing their own time and place to act, sometimes in a process of collective creation.[24]

There are proposals that work out as differentiating extensions of some cultural institutions, mainly within universities,[25] exerting autonomy in their actions. On the other hand, artistic interventions of institutional criticism creatively question the art system and its procedures—curatorial work, selective processes, political culture

21. And also the *Alpendre* (Fortaleza); *Areal* (Rio Grande do Sul); *Vitrine Efêmera*, *A gentil Carioca*, *Casa 85*, *Bolacheiro*, *Bananeiras*, *Galaxy*, *Polígono*, *Palídromo*, *Fogo Cruzado*, *Cristo Vermelho*, *Esquina* (Rio de Janeiro); *Espaço Lilituc*, *Betobatata*, *ACT* (Ateliê de Criação Teatral), *A Grande Garagem que Grava*, *Companhia do Abração*, *Espaço Umbigo*, *Cine*, *Estúdio Matema* (Curitiba); *Ônibus + Museu do Poste* = *Elevador* (Niterói/Curitiba); *Escritório de Arte Glauco Menta with the Projeto Tarsila do Amaral* (Curitiba, 1996); *Submarino e Moluscos Lama* (Recife); *Casa da Grazi*, *Centro de Contracultura de São Paulo*, *Espaço Coringa* (São Paulo); *Coletivo rua* (Americana–SP), *Entorno* (Brasília).

22. And further: *Almanaque*, *Alfândega*, *Orlândia*, *Rio Trajetória*, *Fumacê do Descarrego*, *Imaginário Periférico*, *Inclassificados*, *Sissoma*, *Única Cena*, *Push*; (Rio de Janeiro); *Dia do Nada* (done in Londrina); *Ciclo de Ações performáticas*, *Desafiatlux* (Curitiba), *Manifestação Internacional da Performance* (Belo Horizonte).

23. And beyond the ones that are listed above, there are *Alpendre* (Fortaleza); *Rés do Chão*, interdisciplinary colloquium *Resistências* (Rio de Janeiro); *CEIA–Centro de Experimentação e Informação de Arte* (Belo Horizonte); *EPA!* (Expansão Pública do Artista), *ACT/ Ciclo Multi-área*, *Companhia do Abração*, *Espaço Ícaro*, *Arcádia*, *Espaço Umbigo*, *Encontro Conversa*, *Amigos dos Amigos* (Curitiba); *Centro de Artes* (Curitiba, 1997); *Escola de Artes Leila Pugnalone* (Curitiba, 1998); *Trapler* (Florianópolis).

24. *spmb* (Brasil and Canadá), *Maurício Dias and Water Riedweg* (Brasil and Suíça), *Camelo* (Recife); *Vivia 21 and RhR*, *Rradical*, *Chelpa Ferro*, *Rosana Ricalde e Felipe Barbosa*, *Chave Mestra*, *Grupo Vapor e agentedupla://* (Rio de Janeiro); *Grupo Urucum* (Macapá); *Grupo Empreza* (Goiânia); *Clube da Lata e Laranjas* (Porto Alegre); *Grupo Poro* (Belo Horizonte); *Bijari*, *Anomia*, *Radioatividade*, *Mico*, *Contra–Filé* (São Paulo); *Transição Listrada* (Fortaleza), *Vaca Amarela* (Florianópolis); *Interlux–ArteLivre*, *Coletivo Azulejo*, *Vitoriamario*, *Pipoca Rosa e Pelos Públicos* (Curitiba), *Ponte 6* (Niterói).

25. A few of these proposals derivating from university institutions are *Arte Construtora–Ilha da Casa da Pólvora* (UFRGS, Porto Alegre); *Arte Contemporânea na Universidade* (UFPR, Curitiba, 1995); *Fronteiras e Arte e Política* (festival de Inverno UFPR, Antonia–PR); *Galeria da Cal* (Brasília); *Bienal da Une* (Salvador, Rio de Janeiro, Recife, São Paulo).

and social involvement, exemplified in works such as *Vazadores* by Rubens Mano, *Projeto Camelô*, by the spmb group (Eduardo Aquino and Karen Shanski), *Foi um Prazer*, by Jac Leirner, *Panorama 2001*, by Carla Zaccagnini, and *Ocupação* (produced by myself).[26]

Some *artists' groups* act through multiple strategies and in many different places, sometimes grounded on humour and social irony,[27] while others blur the boundaries between art and culture, for instance, as in the artistic actions coordinated together with the radical social movements, or together with groups of the socially excluded, or generated in specific cultural communities and "alternative societies." The movement *Integração sem Posse* in São Paulo, and the *Casina Project* by Carla Vandrami both are more directly involved in these environments of social conflict.[28]

Circuits are also performed around reflection and practice about the phenomenon of the media: internet, video, community sites, blogs, free TVs and radios, electronic and printed magazines, posters. These vehicles become priority networks for information generation and idea circulation, stimulating "independent productions" and critical reflection about the means of mass communication, also spreading concepts such as *copyleft, free software, digital inclusion, Net and Radio Activism*. In the artistic/cultural media guerrilla field, one finds *A revolução não será televisionada* (São Paulo); *Atrocidades Maravilhosas* and *PHP* (Rio de Janeiro); *Noninoninoni* (Recife); *Yiftah Peled with Performance em outdoors* (Curitiba/ Florianópolis); *Ari Almeida and other members of delinqüente.bloger*, and *Organismo. blog* as well (Curitiba). These have sparked an important social critical friction in and around mass media, while *CORO, Rizoma.net* (both in São Paulo) and *Canal Contemporâneo* (Rio de Janeiro) are important and distinct exchange nets of information.[29]

Other political possibilities for the heterogeneous circuits are affected beyond the artistic self-management of spaces and programs

26. And even: *Concurso Mickey Feio* (Recife and Rio de Janeiro); *Açúcar Invertido*, and *Parangolé vídeo—action register of Cuquinha* (Rio de Janeiro); *Linha Imaginária* (São Paulo and many other cities); *Remetente e APIC!* (Porto Alegre); *Aleph* (Recife); *Rejeitados* (many cities/ Salvador); *Lau* (Guerra dos Mundos), *Escritório* (Curitiba).

27. It is the case of the *Associação Internacional dos Colecionadores de Botão* and it's derivatives: *Museu do Botão, teatro de Boné, Espaço Lilituc, Culto Anual Deus é Umor da Igreja da Salvação pela Graça, Concurso de Assoviadores do Fiu-fiu Esporte Clube, Escola de Samba Unidos do Botão*, etc, all in Curitiba.

28. Further: the communities associated with urban cultures such as hip-hop, street art and punk, with their own practices and aesthetics, including graffiti, road stickers, and magazines; the artistic actions generated in traditional communities or ethnic groups, etc, for example *Revelando olhares dos moradores da Ilha do Mel* and *Projeto Superagui/ EPA!*, both in Paraná. In the field of art linked to "differentiated" ways of life within a society, the *Encontro das Comunidades Alternativas* ENCA (Annual and nomad); *Família Horn e Magrismo* (Curitiba). In the cultural mediation sphere and anthropological transit, the actions and products of *Urbenauta* (Curitiba, São Paulo , etc). And, in a completely inverted meaning, inside the logics of mass communication and cultural television industry, the ironic products form the *Organização Tabajara*— from the *Casseta & Planeta group*.

29. One of the first Brazilian art groups to investigate in a systematic way issues linked to media was *Corpos Informáticos*, from Brasília, still active today. Eduardo Kac has taken robotic art to an extreme technological point, robotics to genetics, as well as creating a performance and action net in *Telepresença*. The perspectives are opened: *Mídias Táticas, Videobrasil, Bijari, Formigueiro* (São Paulo); *Cubo Branco, Leisle.com, Animalice, Meio* (Rio de Janeiro); *Telefone Colorido, Carga e Descarga* (Recife); *Organismo. Blog, Listaleminski, Luciano Mariussi* (Curitiba), *Super Loja Show, A mostra grátis, Terça de Vídeo, Organização, Miscelânea, Cachaça Cine clube* (Rio de Janeiro); *Última Quarta* (Brasília); *Circuitos em Vídeo, Vide o Vídeo, Onanistas, Cine Olho, Pêra, Putz* (Curitiba); *Item magazine, Capacete newspaper, O Ralador, Nós Contemporâneos, Global Brasil* (Rio de Janeiro); *Coleção de livros de postais do Betobatata* (Curitiba), *impressos do Torreão, Perdidos no Espaço* (Porto Alegre); *Número magazine* (São Paulo); etc.

in individual proposals that became circuits when built in collaboration, mainly through creative participation, generating a closer relationship with "the other." This is a processional orientation found at the core of many works by Maurício Dias and Walter Riedweg, in Ricardo Basbaum *(NBP – Novas Bases para Personalidade, Eu/Você)* as well as Giordani Maia *(TCAS– Tentativa de Construção e Aplicação de Sistemas)*.[30]

There are distinctions between *art modalities, circuit-works and heterogeneous circuits*. Land art and video art, for instance, are strategies expanded as investigative conceptual and aesthetic means, which could be understood as artistic modalities more than as circuits. Among the modalities that are more often capable of producing a collective identity charge and affirming a circuit, one finds *mail art, net art and art magazines*. Circuit-works are very specific proposals to precisely make apparent a certain circuit, potentializing its existence by re-signifying to an extreme its structure. This ends-up draining to the last drop the possibility of new forays and participation, kind of turning the circuit into a unique work, as in *Cowboy com cigarro*, by Hans Haake, or *Eppur si muve*, by Cildo Meireles.[31] In contrast, the *heterogeneous circuits* are located in a sphere of happenings in which more particular characteristics associated with a group, place and time are perceived. They are not necessarily linked to a category or specific art form. Rather they are open to cultural multi-patterning;[32] they are *über-languages*, circuits built generally on collective empowerment and on affinity networks, creating a singular and participatory field.

History

There are certain antecedents in dialogue with these contemporary circuits. In Brazil, the *Semana de 22* experience and the *Klaxon* magazine were cultural actions built as "independent events" and "vehicles for ideas' circulation," generating *circuits* and promoting the first great rupture in Brazilian art: *Modernism*. Nearly at the same time,

30. Rubens Mano (Ação comum, calçada), Rosângela Rennó (Arquivo Universal), Goto (Contatos, Remix Corpobras), Rubens Pileggi (Santa Imaculada), Martim Groismann (Polvo), Marssares (Poema; Consumo de Imagem: Infração), Jarbas Lopes (barraca, Troca- troca), Ducha (Nazy Gay), Ana González (cada vez maior e mais perto de você); Cláudio Alvarez (Instalação para viagem), João Modé (Solte seus desejos), Mônica Nador (pinturas de fachadas em casas populares), Eliane Prolik (Kombi), Tânia Bloomfield (regras de ouro para uma boa performance à mesa), Alex Cabral (grafites de rua), Octávio Camargo (Pé com cabeça Museu do Poste), Margit Leisner (ônibus e Livro-caixa), Simone Michelin (Santinho), Romana (oinusiado), Laura Miranda and Denise Bandeira (Meio líquido, Spirare), etc.

31. And also Antoni Muntadas (Comemoração); Arthur Barrio (4 dias e 4 noites); Luta Wanderley (passos que vêem); Goto (Arte para Salão), Rubens Pileggi (pescando Tubarões), Cristiane Bouger (Sensuality in (and) América), Marta Niklaus (Bandeira de Farrapos), Marila dardot (Desapego, Coleção de readymades).

32. The term multipattern used here is inspired by Hélio Oiticica, based on Stéphane Huchet analysis. Huchet, Stéphane. Arte contemporânea: corpo ativo. Text from the lecture delivered at *Corpo em Expansão– X Encontro do PPGAV–EBA–UFRJ*, MAM–RJ Cinemateca, November the 4th of 2003: "The body acted out and inside and through the corpus that is contemporary art is, creates a kind of wide territory wherein the local and the global of the human situations move. I see in this a way of symbolic structuring that makes me stress once more that Oiticica was premonitory when, instead of talking about "multimedia"– in order to create this territory, the possibility of "using" the multiple resources existing in art, both the more traditional as the most innovative supports–he talked about multipatterned propositions, harking to the deeper aspects of perception, as in the idea that "body is the unconscious."

the musician, painter, shaman, anarchist-socialist, pacifist and visionary Bruno Lechowski was placing in public squares and urban centers his circuits strategies as a means to display his paintings: the *Cinetton*, a collapsible tent, *nomad museum*.[33] With it he travelled the world, visiting European cities beginning in 1925 in his native town, Warsaw. Later he landed in Brazil, where he visited Curitiba, São Paulo and Rio Janeiro, the city where he lived until his death. In addition, he was one of the founders of the *Bernardelli Nucleus*. Lechowski was searching for a direct and stable relation with the public; he understood art as experience and knowledge as something to be shared openly. He did not sell his work; he did not want it to belong to any one person. Instead, he considered it to be a "public utility," requesting an entrance fee for his exhibitions, as a means of survival. He developed other innovative projects, such as many collapsible *"showcases"* and even interactive pieces built in conjunction with the painting exhibitions. All of Lechowski's work was aiming at an even bigger project, *A Casa Internacional do Artista* (The International Artist House), "the nest wherein the pure value conception or art for humanity must be rehabilitated and be born again, and the artist's mission, those sons of all people and intimate brothers by vocation, should develop in the present for the Future." Contextualizing with precision some artistic circuit relationships, articulating with independence the public circulation of his works and conceiving in an amplified and libertarian way the social place of the artist, Bruno Lechowiski could be considered a precursor to the *heterogeneous circuits* in Brazil.

And beyond these antecedents, some other actions and movements could be remembered as a polyphonic base of dialogue and productive memory: *Dadaism* (especially Berlin Dada: John Heartfield, *The Dada magazines*, etc.[34]), *Russian Constructivism, Bauhaus, Experiência n 2 and New Look*, by Flávio de Carvalho (1931 and 1956); *Revista Joaquim* (Curitiba, 1946 and 1947), and the groups *Cobra, MADI, GRAV, Fluxus, Coletivo de Arte Sociológica, Art Language; Parangolés* by Hélio Oiticica; *Opinião 65; 7,000 Oaks* by Beuys, among others of his activist art actions based on the concept of social sculpture; *Caminhando*, by Ligia Clark; *Do Corpo à Terra* (Belo Horizonte, 1970), *Domingos da Criação* (Rio de Janeiro, 1971), *Sábados da Criação* (Curitiba, 1971/1972), *Prospectiva e Poéticas Visuais* (MAC-USP, 1974/1977), *Inserções em Circuitos Ideológicos*, by Cildo Meireles; *Troxas ensanguentadas*, by Arthur Barrio; *Porco Empalhado*, by Nelson Leiner; *Copobra*, by Antônio Manuel; *the Grupo Rex collectives, 3Nós3 and Manga Rosa* (São Paulo); *Arquivo Bruscky* and the mail art collective shows, 3X4 photographs and Super-8 fims (Recife); *Intervenções em outdoor*, by Nelson Learner (São Paulo, 1968), and the outdoor intervention collectives *Arte Paisagem* (Curitiba, 1977), *ArtDoor* (recife, 1981 and 1982), in Porto Alegre, and in São Paulo (1982 and 83); *Espaço Nervo Ótico* and *Terreira da Tribo* (Porto Alegre); NAC (João Pessoa), *Visorama* (Rio de Janeiro), process-books collectives by Ângelo de Aquino and Curitiba: Museu de Arte do Paraná, 1991: 17. OBS: even if the second version of the nomad tent for the exhibition was named Cineton, I consider that this concept could be applied to the first model too, because it was the same idea. Bruno Lechowiski's tents are, therefore, Cinetons.

33. In 1932, during the opening of the Casa Internacional do Artista, Lechowiski defined the Cineton: " Movement. Energy. Life that is renewed. Idealism in Continuous Action. The man who lives by the quill is, as a painter, an artist—of the word, of thinking, of the idea. The worker who works by the forge , the man who drives the streetcar, the phone operator, the driver, the doctor, the lawyer, the typesetter, the painter, the journalist. All of them, without exception, fit into the Cineton word." The biographical and historical facts on Bruno Lechowiski, his work and talks are based on research from Vianna Baptista, Christine. Bruno Lechowiski, *a arte como missão* (art as a mission).

34. See: Baitello Júnior, Norval. Dadá Berlim: des/montagem. São Paulo: Annablume, 1994:98.

Paulo Bruscky; and even *Encontros de Arte Moderna* (1969-1974), *ArtShow* (1978), the *Moto Contínuo* and *Sensibilizar* groups (1983 and 1984), the *Museu do Botão* collective (since 1984), these all taking place in Curitiba. And so on.

With history linked in this way, it is clear how much artistic production is capable of searching for new relational critical configurations with the social environment, transcending time and geographical limits, constantly conceptualizing new configurations as a political possibility. Therefore, even the 1980s, dubbed as the "return to painting" period, should not be thus simplified, even if that tendency and the marketing of that kind of art were indeed predominant. Besides, many artists acting in the context of that generation and in the transition into the 1990s, were the first ones to perform some of the more resonant actions in the heterogeneous circuits in contemporary Brazil,[35] a phenomenon also verified worldwide.[36]

Dangers and Potentials

When cultural institutions, art museums, critics and even gallerists from the establishment felt the tide splashing up their arses, as we say here in Brazilian low culture, they cast a glance towards the theme of art and politics, many of them being the very ones who had dubbed that possibility as aged, overshot, minor. There are exceptions, of course, a few people within history. However, the apparent U-turn is due to, above all, a new attempt to maintain control over artistic discourse and the social mediation of art (with a good measure of hypocrisy). It is even possible to imagine the Brazil Connects company promoting a mega-exhibition on Brazilian art with a political touch in the Venice Biennale, with a First World cocktail...POP us out of that!

On the artists' side, it is important to remember that the *artistic circuits* and collectives could mean little or nothing if they are not a result of a critical stance and a real collective necessity. Collectives for the sake of collectives can be hollow, as in art for art's sake...neo-Nazis and Corporate Society business groups also form collectives. If something that should be critically resistant, articulated theoretically and materially manifest in society becomes simply a fake difference, a made-up resistance of easy assimilation in the contemporary "anything goes," as noted Hal Foster,[37] then the social traps are more subtle and sophisticated. *Heterogeneous circuits* are transformed into *circuits in bionecrosis* if only style prevails, devoid of values, acting as mere springboards for visibility in the same traditional system of power networks. Besides,

35. Elida Tessler e Jailton Moreira with Torreão; Ricardo Basbaum, Eduardo Coimbra and Raul Mourão with Agora; Helmut Batista with Capacete; Riacrdo Pimenta, Luís Sérgio de Oliveira, Ângelo Marzano, Fernando Borges and Fuad Hajjat with a Galeria do Poste; Oriana Duarte, Marcelo Coutinho and Paulo Meira with Camelo.

36. Transmission (Glasgow), City Racing (Londres), Artemísia (Chicago), Catalyst (Belfast), Generator (Dundee), Magnet (South Africa, England, Mexico, China, Porto Rico, Brazil, Trindad Tobago, India), Critical Art Ensemble (USA), Espacio Agluitnador (La Havana), Galeria Metropolitana (Santiago), Espacio La Rebeca (Bogotá), Hoffmann's House (Santiago), Trama (Buenos Aires), Duplus (Buenos Aires). See: http:www.trasmissiongallery.org/ ;http://proyectotrama.org and Basbaum, Ricardo. Gestos Locais. Efeitos globais. In: Barros, Ana, Santaella, Lucia. *Mídias e Artes: os desafios da arte no início do século XXI*. São Paulo, Unimarco Editora, 2002. Among other collective actions, it should be important to note that the Art Service Association, founded by Boris Nieslony, and it's beginning hark back to the 70s, functioning as an organism and self-managed field, focused chiefly on the production and reflection around world performance. See:www.asa.de

37. "This anxious search (for the difference) can also promote the creation of false differences encoded for consuming. And, if the difference can be fake, resistance could also be." Foster, Hal. Leituras em Resistência Cultural. *Recodificação, Arte Espetáculo, Política Cultural*. São Paulo: Casa Editorial paulista, 1996 : 225.

the fashion of collective multiplication could even set up a passive representation of the individual before the collectivity, as in a "dictatorship of the collective process." Or, it could stimulate cultural ghettoes, eugenics groups, with no symbolic exchanges with society. Then, beyond the conclusion that *the revolution will be televised*, we arrive at a point wherein it is not even wished. It is a *doesn't matter generation*. Because the "thing" became to "shoot in all directions," to make it, be on the map! Born to be famous.[38] Sorry, smile.

Heterogeneous circuits are involved in the warmth of a global hopelessness—amid wars, intolerances, empires, markets, wealth concentration and much corruption—watching out, however, for the possibilities that are waiting in the wings and focused on the potential of critical and emancipating action. These circuits can constitute a radical resistance perspective and a cultural proposition: in the breakdown of paradigms linked to a sense of center and periphery; in the affirmation of alternative institutional control over discourse; in the autonomy of dialogue; in the building of new economic relationships, in *transversalization of self-referencialities* (Felix Guattari); in the proposal of different ways of consciousness and companionship. This is the tensed surface and the political "arena" wherein the art action circulates.

[38] Fernandes, João. *Born to be famous: a condição do jovem artista, entre o sucesso pop e as ilusões perdidas...* Ferreira, Glória, Venancio Filho, Paulo. *Revista arte & Ensaios* n° 10. Rio de Janeiro: Editora UFRJ, 2003 : 126.

isnt it great that we have spaces at all where before there was nothing and Im sure we must be part of some larger plan the arts council has for us and the thing to do is just get on with it and be thankful to the sweet and divine that we have a space at all to do the dreaming nobody knows what you need for that broadband is it and plenty of electrical outlets but as sure as Christ whatever you put in will be obsolete next year and somebody will discover telepathy or something and artists will just lie in bed thinking

—NOEL SHERIDAN

Aoife O'Brien

THE ART SPACE IMPERATIVE— A RECENT READING

A Joycean spiel by Noel Sheridan captures the key ideas that cut through the recent publication *Space: Architecture for Art*—how to satisfy artists, architects and public when creating gallery and arts center buildings—and conveys the confusion that clouds compromise between practical architectural discipline and artistic licence.

This muddy and stimulating seam of thought was not immediately apparent when I opened the book; the publication is in two clear sections, the first a series of essays and discussions from different perspectives of art and architecture, the latter a directory of Ireland's art spaces. Unlike readers with admirable self control who consume a book front to rear cover in a linear fashion, I headed first for the second half where the merits of well-known and respected art spaces such as IMMA, the Ormeau Baths Gallery or new Lewis Glucksman Gallery are compared with the lesser known Clotworthy Arts Center, Cavanacor or Butler Galleries, to take a random sample. *Space* is an impressive endeavor supported by both the Arts Council of Northern Ireland and An Chomhairle Ealaíon/The Arts Council with further backing from galleries, architectural practices and cultural institutions. Over 200 art spaces of varying sizes and remits are listed, and while some may seem relatively parochial, the book should not be faulted for being comprehensive.

Several authors acknowledge the legacy of Brian O'Doherty's work *Inside the White Cube*, and he prefaces this book. In 1976 Doherty first questioned a gallery context graven with the meaning that its content has been stripped of, or liberated from. Thereafter we had even less excuse to pretend that the museum had ever been a constant entity, nor could we ignore the economic, social and aesthetic network within and without a commercial or public gallery which sustains it. If the art environment is now a "white ideal space that, more than any picture [is] the archetype of the 20th century" and artists, curators and gallery-goers unconsciously read this vocabulary, architects cannot be naïve about the spaces they are called to design.

Space is a localised investigation, divided into chapters looking at the process of commissioning new art venues; how space works for or against art and how art interacts with different spaces; investigations into current provision and case studies; results of a recent poll to find the architecture that suits everybody (and possibly no-one); and a wish list of inspira-

tional spaces worldwide. While the perspective throughout is cosmopolitan, most authors eventually apply their thinking to the Irish cultural landscape. Contributors sit on either side of the architecture/art fence when describing the ideal art space, and many Irish critics are also paint-splattered practitioners, or gallery managers, or curators. Few architects unfortunately job-share in the same manner, and architects come out marginally the underdogs. Fortunately John Gerrard remembers that artists are not entirely altruistic; they "may well want to create liberated dialogues. Their own liberated dialogues in which the exhibition environment may or may not get a look in."

Voices repeatedly to lament how art space commissioners or planners are ignorant of, or ignore, the practical needs of artists and curators. Several overtly architecturally impressive civic arts centers have been designed that cannot accommodate many art works due to access that is not large enough, uncontrolled light, inflexible or unusable walls and poorly positioned power points, let alone wireless networks. On the other hand, it is within architects' remit to orchestrate movement around buildings, to enable ideal focal distances and ultimately to integrate the needs of all users, be they art professionals, weekend visitors, school groups, tourists or committed enthusiasts. And the reader should beware the bias of the art professional - anyone who has seen that clique descend upon a biennale opening knows their experience of art can be far from the norm. While there is great wisdom in involving artists and curators in the design process from inception, the relationship between budget managers and programmers should also be ultimately pragmatic, rather than rivalrous. Cultural venues do not run on thin air, and artists do also, we know, need to eat; that said, when planning sustainable economic venues, as Gemma Tipton writes, "art does not necessarily have an unlimited and renewing reserve of cultural value to confer before the reciprocal nature of the exchange begins to have a negative impact." Creating more arts venues such as Dublin's Arthouse that closed in 2003 after 7 years, Derry's now defunct Orchard Gallery or the Baltic in Gateshead, which struggles to find audiences and funding, will serve nobody's interests.

It is to *Space's* advantage that it considers the issues relating to Ireland's landscape and is not in thrall to major international gallery trends, but applies current ideas and recent

learning to national or regional venues, whatever scale they may be. The outsider reader might be tempted to dismiss this landscape as irrelevant, in particular given the major role of the Arts Councils, but Arts Council support has created an opportunity to reconsider the pivotal question of why burghers require arts centers in the first place. Municipal galleries in particular have a duty, albeit a difficult one, to a population; despite the unflattering comparisons to churches and supermarkets, a gallery provides a meeting place and a fulcrum for creativity (though its creative potential is limited if it is relegated to a corridor between local library and theater). In context, arts provision and programming form the identity of a region. Architects do not have a divine right to impose their statement buildings upon artists or communities, though drama in the design helps compensate where galleries cannot afford to compete for attention with their collection. Better the overt statement than the cultural quarter created to bring wealth and economic development, which does so at the expense of the practising artists forced out when they cannot afford to pay the prices of gentrification.

The municipal arts center cannot always accommodate a white cube, let alone its accompanying baggage. A minor municipality may not recognise the "sacred" space accepted in the metropolis, or not want to buy into the social and economic network of the big-name gallery paradigm. Without this tacit understanding, it becomes a tall order to communicate an art space's necessity. On the other hand, regional public sector planning gives a gallery some chance of existing as a platform for art and as a resource which a community can voluntarily enjoy. Meanwhile, our major museums struggle with the obligations to educate, inform, multi-task, pay their way, attract major donors, revivify their environments and to be beacons attracting short-sighted tourists blind to buildings not signed Hadid, Gehry or some such.

Space makes a convincing argument for collaboration; the desires of the local authority, architect, curator and artist need not be mutually exclusive. Given that the white cube was never a neutral space, architecture has a responsibility to create more than blank walls but rather rooms that entertain the transient dialogue of art within them. After all, as Allyson Spellacy rightly points out, "caverns are yawning for a reason."

Space
Architecture for Art
Including a directory of arts spaces in Ireland
Edited by Gemma Tipton

CIRCA, 2005

Sophie Warren & Jonathan Mosley
"Blue Sky Thinking," 2005
1100cm wide x 1750 cm deep x 221cm high
Found cardboard, emulsion paint and PVC tape

Robin Wilson

BLUE SKY THINKING:
A UTOPIA IN BRISTOL

Like many regional cities Bristol is currently engaged in a rapid and sustained process of change. The docklands and river frontages have now undergone multiple phases of redevelopment; new public works have transformed the facades of central institutions; housing and corporate office projects have massively extended the outer limits of the city and fundamentally altered its relationship to the wider landscape.

Artists and architects are of course involved in such processes in diverse ways: as participating agents of redevelopment (new build construction and refurbishment, public art in the docklands, landscaping in the peripheries); and as observers or critics of the effects of change or the discourse of redevelopment (for instance, *Thinking of the Outside*, an ambitious program of situated art works shown in Summer 2005, subtly registered the gap between the city's contemporary culture and historical identity).[1] Typically, the latter category—observance of the aftermath—has often produced by far the more interesting results.

The work of the Bristol based artist/architect collaboration Sophie Warren and Jonathan Mosley could be said to have occupied both territories in recent years, taking the form of architectural construction and critical observation through event-based works and installations. In 2002 they completed the construction of their own house in the Redcliff area of the city. The project was one in a number of small-scale property developments in the area, the rate of which has subsequently increased, echoing the broader pattern of destruction and renewal across the Bristol agglomeration. From 2003–05 they worked on numerous urban-related art projects exploring, for instance, in a work called *Area of Reunion*, the balance between officially programmed spaces and those less determined or interstitial spaces of the inner city. But active in either mode their work has consistently exhibited a core preoccupation with the process of change itself and with the opportunities that transitional spaces and conditions can offer. In their most recent work called *Blue Sky Thinking* this concern for the transitory and the indeterminate has also given rise to an explicit utopian dimension to their work. This article explores the possible meaning and function of this utopianism as it surfaces against the backdrop of the realities of urban renewal.

1. Claire Doherty (curator), *Thinking of the Outside*, Bristol, 21st May – 3rd July, 2005.

Through *Blue Sky Thinking* Warren and Mosley have come into contact with the active frontier of inner city regeneration. Its venue was a gallery called Plan 9. But this essentially comprises an abandoned shop (to be precise, the old Beatties model shop in Penn Street) and bears little resemblance to the classic gallery as such. The gallery and its works are exposed to a more-or-less seamless relation with its immediate context: a 1960s shopping zone (the Broadmead) which is soon to be destroyed and redeveloped.

Before I turn to the contents of the model shop of Penn Street, let me take you one step further back, to the invite card to the show. One side of it is just image. It shows a grainy black and white photograph of a hand pointing downward to a monumental city-scape. It is, as is explained on the other side of the card, an archival fragment from the 1920s, being the "hand of Le Corbusier over a model of the Plan Voisin"—Le Corbusier's proposal for a vast city of towers near the Ile de la Cité. The title of the exhibition also appears on that other side along with the following description of the installation:

Blue Sky Thinking brings the remains of a consumer age into playful collision with the utopian and the architectural. An imaginary model world is constructed. Three grids act as tectonic plates for three landscapes. One holds a city of towers, one the extremes of suburbia,

Sophie Warren & Jonathan Mosley
"Model Superimposition," June 2002
Figure, model scale 1:50, site

one a sublime mountainous terrain. Architectural motifs occupy these dreamlike spaces and suggest other narratives. The blue of light catches a surface revealing an idealised landscape built on the leftovers of commerce.

No explicit mention of context appears in the introductory text. However, it would seem that the image of the Plan Voisin could relate both to this promised utopian dimension in the work and to certain contextual themes. While representing what might be defined as a conventional definition of the utopian in architectural terms—a radical new program for urban living—it also highlights the contextual themes of both model making and redevelopment.

Surely we would be wrong to assume that by reproducing the image of the Plan Voisin Warren and Mosley also seek to replicate the ideological assumptions of the discourse behind it—that is, concerning utopian socialism, modernity and progress. But neither is there evidence to suggest that they reject the utopianism of Le Corbusier as such. Rather, it would seem that the hand of Le Corbusier has been displaced so that it too enters into a kind of "playful collision" with numerous other "hands"—from those of the contemporary developer or council planner, to the hobbyist model maker, to, indeed

Sophie Warren & Jonathan Mosley
"WAS HERE," June 2002
Black & white emulsion
Scale of text 0.55m x 4.15m

their own. We could say then that the image of the Plan Voisin is not simply an historical reference as such, but in fact has a more complex temporal status, linking, through the shared motif of the model, the temporal categories of past, present and future.

For those at all familiar with the work of Warren and Mosley the appearance of a hand within an image would perhaps have already prompted memories of other previous works, for the hand and arm of Sophie Warren has quite frequently been used as a pictorial motif. Of particular relevance for our purposes here is one of a series of works produced during the design and construction of the house in Redcliff and which appeared on the front cover of *The Architects' Journal* on the 31st October 2002. It shows the hand of Sophie Warren holding a scale model of the house in front of its future site.

This image also has a curiously indeterminate temporal structure. The model, product of the phases of design anterior to construction takes the place of the future completed building, while at the same time, through the implied tension of the hand attempting to keep the model in perfect alignment with the site, it also has a strong indication of present time, the duration of the moment of photographic documentation. Moreover, a concern for the indeterminacy of temporal categories also appeared in other works developed during

the construction of the house. Evolving a previous interest in graffiti in the city, one was a text piece written on the side elevation of the house. It comprised the words WAS HERE, written in a large, regular font, washed over a few times with the white paint that covered the rest of the elevation. At the time, the elevation overlooked an empty plot. Now it is covered by a subsequent development of terrace housing. Here then, past, present and future collided again. The past tense statement inferred a future disappearance and also drew attention to the time of viewing, the transitory nature of the present appearance of things. But the WAS HERE text also seemed to offer a somewhat melancholic reflection on the process of architectural production itself. It seemed to suggest, that in the building's completion, and at this point of symbolically signing off (as if the building itself had made its mark of authorship on its own exposed flank), the dream of the building as idea had itself come to an end. Completion, implied the hand behind WAS HERE, is a kind of death. Perhaps the text in fact implied that all architectural production involves the transition from ideal to the real, and that completion exposes a utopian longing, which can never truly see the light of day.

If a utopian dimension was implicit in the works produced during the production of the Redcliff house, then, as the invitation card to *Blue Sky Thinking* confirms, it has become an explicit part of Warren and Mosley's work now. Indeed the title itself leaves us in little doubt that they have become engaged in that particular mode of thinking that we usually understand to involve day dreams and ideals.

The Model Interior
The carpet of the Plan 9 gallery is light green and coarsely fibrous like a degraded Astroturf pitch. It is the perfect recipient surface for a new model world. Give me some license at this point, for I have a desire to rename this space—or rather, the synthesis of this space and the Warren and Mosley installation. Let me call it "Planet 9," like the scene of some minor sub-plot in a sci-fi novel by Isaac Asimov or Doris Lessing.

The three great continents of Planet 9 cover about 15 square metres, with narrow ocean channels of circulatory space—empty green carpet—between them. Vast quantities of neatly cut cardboard boxes provide the building material for its cities and landscapes, and a light-colored tape marks out their respective grids. The installation was clearly the result of considerable labor. To the front and east side of the shop space rises the "city of towers," about two and a half meters tall in places, built of cardboard "bricks." To its immediate west, is the grid of "suburbia," with its "endless" spread of single storey houses, occupying their individual plots. (it is indeed endless, for its image is reflected in a mirror panel in the sidewall of the shop window). To the rear is the "mountainous terrain"—a mountain range of card board off-cuts, truly epic in scale, suggesting, like the "cities" themselves, that the nearest equivalent topographies in our home world, natural and built, would be those of the Americas.

Sophie Warren & Jonathan Mosley
"Blue Sky Thinking," 2005
1100cm wide x 1750 cm deep x 221cm high
Found cardboard, emulsion paint and PVC tape

As one starts to explore these three continents certain other elements start to become apparent, making the tripartite division of this world somewhat less definitive than at first glance. To the rear of suburbia, just outside its grid, is a kind of compound structure: four bricks arranged in a square form a courtyard in which three further triangular structures are placed, resembling pitched roof sheds. It clearly represents some kind of "gated"— protected or isolated—community. Its closest resemblance is to a prison or a fort perhaps. To the rear of the mountain range is a single dwelling—a brick block with a pitched roof. It would seem to be the archetypal cabin in the wilderness. At the center of the city of towers a quite odd, seemingly unrelated structure appears, which Warren and Mosley refer to as "the platform." Unlike all the other structures in Planet 9 this one does not have any immediate correlation to the typical living structures of our home world. It comprises a block—about two stories high when compared to the adjacent towers—but with a staircase winding around its outside, which leads onto a flat roof. Although considerably smaller than any of the tower blocks, it occupies the same scale of grid division. It has been privileged with the luxury of empty space around it. Could this be some kind of ceremonial building, perhaps a center of governance, or the central temple of the city's religion?

Within the grids of suburbia and the city of towers smaller model details start to articulate a more intimate level of engagement with the "life" of these cities. Some of the tower blocks have simple lean-to structures at their bases. In both cities chairs appear here and there. For instance, in suburbia two chairs are angled toward each other across the dividing line of the grid division (the chairs seem just slightly oversize in scale). In the city of towers a cluster of three has been deposited at the base of one of the most easterly tower blocks, looking out beyond the limits of the city and toward the mountains.

The relational complexity of this imaginary world increases with each look. In the city of towers certain blocks have sections extracted. Some grids seem to contain only the beginnings of buildings, the first slab work of new super blocks. To its west side, one grid division has seemingly been occupied by the same blocks that cover suburbia. And all the west facing surfaces of the city's main tower blocks are painted light blue—presumably that "blue of light" to which the invitation card refers.

How can we begin to decipher this world, for it has the complexity of a novel? Do we read it as a complete system or a series of discrete decisions or incidents? Do all of these nuances have meaning or would some lead us down blind alleys? A thorough and productive analysis of Warren and Mosley's model world would I believe be possible. But it would be a lengthy task, like indeed the decipherment of Thomas More's original *Utopia* or others of that particular literary genre. Here I will have space only to expand upon a few observations.

It is clear that in the production of *Blue Sky Thinking* Warren and Mosley have not at any point indulged in the fantasy of producing an actualizable utopian scheme. It remains at all times conscious of its status as an act of "play." Primary oppositional categories—such as between city and landscape, center and periphery, collective and individual—are given

schematic form through model figures, like the counters in a game of chess. They are assembled into a fictional totality and then become the subject of a complex play of variables and relational contamination.

At what level a viewer engages in that spatial play in the interior of Plan 9 is of course beyond Warren and Mosley's control. But what would seem to be unavoidable, both for dedicated art viewers and passing shoppers alike, is a confrontation with the raw material of the piece: the huge quantities of cut and reassembled card board boxes, the packaging of commodity circulation that provides the building material of these fictional topographies. The fact that there has seemingly been no attempt to edit the appearance of product graphics on the surfaces of the model world suggests that the cardboard box is more than a convenient, free resource, but is also present as the result of a conceptual decision, that must itself inform our reading of the model world.

If cardboard boxing is not transformed here into a "neutral" building material, but remains synonymous with commodity production and consumer society, it would seem

Sophie Warren & Jonathan Mosley
"Blue Sky Thinking," 2005
1100cm wide x 1750 cm deep x 221cm high
Found cardboard, emulsion paint and PVC tape

that Warren and Mosley present a rather dismal prognosis: that we are so much under the grip of our present system—late capitalism—that it has infiltrated into the very substance of the day dream, that it now frames and structures each facet of the utopian imagination. Perhaps it suggests that when, in our reading of the model world, in our negotiation of its conundrums, we think to exercise free choice, we are in fact making no choice at all, but just manoeuvering within a closed system.

If then Warren and Mosley point to the failure of the schemes of the utopian dreamer they would not be alone. For instance, the Marxist theorist Fredric Jameson has frequently argued that utopia can indeed only fail. The prospect of instigating difference or social transformation through praxis is for him a falsehood, negated by the fact that one cannot transform the current system from within; as Jameson puts it, "the real future, if it is radically different from this present will scarcely resemble the fantasies of the present."[2] But also like Jameson, I believe that Warren and Mosley do not, as a consequence, suggest that there is no longer any point to utopian thinking. I believe that *Blue Sky Thinking* is very much of the optimism of the genuine utopian spirit, not its rejection.

At essence, the utopian task challenges us to confront our absolute limits of imagining: to project a world, a way of being, beyond our present conditions of existence and to effectively imagine a future. While the utopian work's "ideal" fictional offering (its future city, or model world) will remain hostage to our own mode of production we can, according to Jameson, gain a kind of abstracted insight about the future from that utopian figure. We can exact upon the utopian work a kind of theoretical scavenging activity, a picking over of the failed effort of the imagination, to consult its structures as they rise into inevitable collapse. Utopias may or may not offer imaginative technical prophecy on how the details of life could be modified. However, as for the more fundamental criterion of difference, of change and becoming in any real, collective and historical sense, the lessons are to be found, as far as Jameson is concerned, in the nuances of utopia's underlying, structural dynamics, in what he terms utopia's "structural inconsistencies." He writes,

> the utopian text really does hold out for us the vivid lesson of what we cannot imagine: only it does so not by imagining it concretely but rather by way of the holes in the text that are our own incapacity to see beyond the epoch and its ideological closures.[3]

The implication is that somewhere within the complex relational moves and spatial play of Planet 9 something radical, surprising, prophetic might indeed occur, or be posited—something by definition outside of the determinate control of the authors' intent. That odyssey

2. Fredric Jameson, "Is Space Political?", in Cynthia C. Davidson (ed.), *Anyplace* (Cambridge, The MIT Press, 1995), p. 197.

3. Frederic Jameson, *The Seeds of Time* (New York, Columbia University Press, 1994), p. 75.

Sophie Warren & Jonathan Mosley
"Proposed Alterations to a City Plan," 2006
76cm wide x 123cm high

A found Corona Extra cardboard box spliced with a City Council Planning Department's Local Plan. A Local Plan is a color coded map designating different uses to areas of the city

of decipherment will not, as I have already remarked, be attempted here and now. But what we can say of the authors' intent is that utopia has been evoked not as some figure of the ideal of progress, nor for the purposes of staging some ironic and pessimistic rejection of the utopian imagination (and its role in the discourse of modernity), but radically as a form of contextual, reflexive instrument.

Neither concretely engaged with the definition of future development nor with its subsequent critique *Blue Sky Thinking* steps outside the loop to offer a playful, fictional figure of the totality: the broad "choices" and dilemmas of our struggle to define a project for collective existence. Like the hand holding the model house in front of its future site, and the WAS HERE text on the side of the realized building, *Blue Sky Thinking* inhabits the indeterminate moment of the city in transition. The utopian is presented here, not as the fixed ideal, the product of the heavy hand of ideological determinacy, but the result of the playful hand, tinkering, like the model maker, with endless variables and evolutions: an indeterminate utopia of process.

Claudine Isé

VANISHING POINTS

THE EXHIBITION VANISHING POINT
WAS HELD AT THE WEXNER CENTER
GALLERIES AT THE BELMONT
BUILDING IN COLUMBUS, OHIO,
MAY 21 – AUGUST 14, 2005.

LUISA LAMBRI
"Untitled (Palácio dos Arcos, #07)," 2003
Laserchrome print, 51.8 x 60 cm, ed. 1/5
Courtesy of Marc Foxx, Los Angeles

In 1978 rock musician and record producer Brian Eno released a groundbreaking musical composition called *Music for Airports*. A minimalist orchestration of piano, synthesizers, tape loops, wordless human vocalizations, and extended moments of silence, the record was inspired by an experience Eno had while waiting for a plane in Cologne. That day the airport was nearly empty, which drew his focus to the terminal's interior. He began to think about a kind of music that would be particularly well suited to this "placeless" type of environment, which was part waiting area, part transit zone. The music would have to be easy to interrupt, allowing for periodic announcements; it would need to differentiate itself from human speech so that it wouldn't be confused with the sound of people talking; and it would need to accommodate, rather than compete with, the existing acoustic atmosphere. But Eno also thought the music should reflect something essential about the experiences people have in airports. It should be ethereal and elusive, and highlight what was extraordinary about an otherwise mundane environment by somehow evoking "where you are and what you are there for—flying, floating, and, secretly, flirting with death."[1]

1. Brian Eno, "Ambient Music," in *A Year with Swollen Appendices: Brian Eno's Diary* (London: Faber and Faber, 1996), 294.

With its techniques of temporal distortion, looped repetition, and extended pauses, the four-part composition that resulted from Eno's musings was radical for its time in part because it left out almost everything that made "popular music" popular in the first place. There was no beat to dance to, no hook, no vocal refrain. Eno called this ambient music: music designed to fill a space by accommodating itself to a particular environment rather than simply blending into it. It was music that was centerless and nonlinear, blurring distinctions between foreground and background by making everything that could take place within the airport part of the overall musical score. It also put the listener's subjective experience at its center, because it was meant to be perceived as part of the background of what was already taking place.

Unlike "canned" music or Muzak, which simply blankets a space with familiar tunes, *Music for Airports* took into account the fleeting perceptions and momentary encounters of travelers as they hurried across concourses, waited in line, gazed out at passing jets, and boarded flights to places near and far. Eno continued to experiment with similar musical structures in his 1976–78 project *Music for Films*. "I found I liked film soundtrack music," Eno said of this work, "because film music is really music with its center missing, because the film is actually the center of the music, so if you just listen to the music alone, without seeing the film, you have something that has a tremendous amount of open space in it—and that space is important, because it's the space that invites you as the listener into the music."[2] As in *Music for Airports*, the insertion of roomy pauses—empty spaces, in effect—enabled the sounds of the outside world to penetrate the composition. The music was subtle enough to fade into the background of the listener's environment, but at times it also had the power to subsume that very environment by subtly coloring it with its own tonal palette. "Immersion was really the point: we were making music to swim in, to float in, to get lost inside," Eno recalled.[3]

Eno's music asserted the importance of background and atmosphere in defining a sense of place, or, as in the case of the airport and other transit zones, a sense of placelessness. In a manner not unlike his, a number of artists today are making paintings, photographs, video installations, and sculptures that use emptiness and an often overpowering sense of atmosphere to portray our increasingly homogenized urban environment, and, even more importantly, to describe the human's place within it. Much of the art in *Vanishing*

[2] Brian Eno, interview by Paul Merton, *Fabulous 1 FM* (Radio 1, BBC), January 1, 1995, quoted on Enoweb, http://music.hyperreal.org/artists/brian_eno/interviews/ambe2.html.

[3] Brian Eno, "Ambient Music," 294.

Point is characterized not only by an absence of the figure, but also by an excess of background. In these works commonplace aspects of public environments that typically go unnoticed—banal corporate décor and the presence of elevators, escalators, fluorescent lighting, and HVAC systems, along with the dings, rings, buzzes, and bleeps emitted by computers, alarms, air conditioners, and automated teller machines—are brought to the fore, while other forms of descriptive information are suppressed. The artists' use of disembodied vantage points evokes the groundless, everywhere-and-nowhere liquidity of contemporary urban experience. With a few notable exceptions, most of these depictions are devoid of human presence. Yet they convey a range of emotional and perceptual experiences—both positive and negative—that the built environment inspires in people today.

Cool rather than hot, the art in *Vanishing Point* tends toward the detached, even the austere. The places depicted are mundane, easy to forget or overlook, and yet the works themselves are anything but banal. Fabian Birgfeld's photographs of airports, subway stations, and hotel lobbies are selected and framed in a manner that estranges these places from the familiar. They have been taken in cities such as London, New York, Los Angeles, Hong Kong, Kansai, Berlin, and numerous others. Viewed collectively, the "interior landscapes," as the artist calls this series, comprise an archive of placeless space within the contemporary built environment. In many of them, we see poster advertisements and graffiti scrawled on walls, but there are no signs indicating what city we are in, much less the name of the airport or subway station. Often these spaces look more like underground cities than they do airports or hotels, attesting to the ways interior space is expanding in a manner equivalent to urban sprawl, with gambling casinos, Internet cafés, and shopping malls, for example, folded into airports or hotels. In many of these images it is impossible to distinguish one type of place from another. When people appear at all, they are mostly unrecognizable blurry smears—like flies trapped between glass windows—or engulfed by the architecture's swooping curves and interior passageways.

34
VANISHING POINTS

In Birgfeld's images, atmosphere takes on a voracious presence, threatening to devour or otherwise overwhelm the solidity of built structures. Similarly, Carla Klein's paintings of empty transportation terminals and other nondescript public spaces are characterized by a sense that solid architectural forms are dissipating. Soaked in hues of milky blue and green, the artworks picture aqueous interiors where shadows morph into walls, windows, and floors, and it becomes impossible to distinguish inside from outside, solid from fluid, fullness from emptiness.

Amy Wheeler's paintings of Los Angeles boutiques at night do something similar. Depicting partially illuminated luxury store windows as seen from her car at night, Wheeler hones in on one of the most common ways of perceiving the urban environment today: through the window of a moving automobile. The fleeting, sweeping glances employed by drivers and passengers effects a kind of dissolution of its own by turning the built environment into something dreamlike and abstracted, a steady stream of colored lights and shadows across a series of reflective surfaces. She translates the multiply mediated, "branded" spaces of Prada or Katayone Adeli clothing boutiques into paintings in which all spatial distinctions, including that between body and environment, collapse. A painting from her Prada Series (#1, 2000) creates a sense of uncertainty as to whether we are staring at a flat surface or into a darkened space. The composition is allover yet minimal, consisting of a few intersecting planes of different densities of black, several diffuse white slashes, and two floating orbs that could be the reflection of the moon against glass or an interior source of light. Like Birgfeld's airport triptychs, Wheeler's paintings divest familiar places of as much information as possible. The fact that these are high-end shops selling expensive designer clothing is less important to Wheeler than the seductive allure of these spaces seen at night through multiple layers of glass.

Luisa Lambri's photographs strip notable modernist buildings of some of their most recognizable features while bringing their atmospheric qualities forward. She transforms famous architectural landmarks into in-between spaces that have been freed, albeit temporarily, from the freighted history of modern architecture. Many of her images play off the signature vantage points through which the buildings have been photographed in the past and with which they

FABIAN BIRGFELD
"Kansai," 2001
3 Cibachrome prints mounted on aluminium
40 x 122 in.
Courtesy of Josée Bienvenu Gallery, New York

are most associated. The difference Lambri brings to her images arises from her sensitivity to recessive elements, such as the quality of light at different times of day, along with ways in which that light can be used to literally carve out space and transform it into something unfamiliar. In this way her strategies for depicting space and place resonate with those of Birgfeld, Klein, and Wheeler. Even though human bodies are entirely absent from her photographs, Lambri's images feel palpably embodied. Her choices of tone, color, and focal length emphasize the artist's subjective point of view. In this way Lambri's photographs do point to the presence of a body—her own—but it is a body situated outside of the image itself.

In Birgfeld's and Lambri's photographs, and Klein's and Wheeler's paintings, there is a curious absence of people. So too, in Teresa Hubbard and Alexander Birchler's photographs of the popular Tinseltown chain of movie theaters: all of the people have been digitally erased. In Dike Blair's jewel-like gouaches of waiting rooms and airport lobbies, all of the chairs sit empty. Corinne Wasmuht's gleaming, mural-scaled cityscape paintings are dense with signs of urban activity—the splash of car headlights on pavement and against the refracting surfaces of glass windows and doors. Clearly there is life here, but there are no bodies in sight. Deborah Stratman's film *In Order Not to Be Here* (2002) portrays contemporary suburbia as a chilling, postapocalyptic realm that is utterly devoid of human beings.

Why are there no people in any of these images? The work of French anthropologist Marc Augé offers insight into the cultural context that this representational absence reflects. Augé argues that societies across the globe are currently in the midst of an emerging paradigm that is dramatically altering our sense of place, on both a local and a global scale. Increased mobility, the advent of worldwide telecommunications, and the ability to compress various forms of media digitally and in seconds send them virtually anywhere in the world—all contribute to the changing notions of what "public," "space," and indeed, "public space" mean today. These trends and technologies also affect our experiences within everyday built spaces like mini-malls, mega-malls, corporate plazas, and high-rise developments. Augé tells us that where once the traditional anthropological meaning of "place" signified an area that acquires meaning

from human activities and interaction, today new types of spaces are emerging that are more accurately described as "nonplaces," areas that are mostly devoid of such socially inscribed significance.

Traditionally, "place" has been inscribed by history and human activity. Often the presence of monuments generates opportunities for social interaction and reflection. Spontaneous and organized group activities and exchanges occur in traditional kinds of places (think of sports stadiums, public plazas, and parks), whereas in nonplaces "the individual feels himself to be a spectator without paying much attention to the spectacle."[4] People are inconsequential to the environment, and in turn the environment bears no permanent traces of human presence. In nonplaces, people relate to one another in an abstract, short-lived, and distracted manner. Nonplaces tend to discourage human engagement other than that dictated by commerce. At the extreme, there is no human exchange at all, just a silent, salutatory text on a computer screen instructing users to insert their card and have a nice day.

For Augé, the traveler's movement through space—experienced as rootless and fluid, with perceptions by necessity distracted and fleeting—creates the archetypal experience of nonplace. Just as global travelers move through generic environments in which "neither identity, nor relations, nor history really make any sense," the freeway drivers or patrons of today's big-box chain stores and shopping malls find themselves in "spaces in which solitude is experienced as an overburdening or emptying of individuality."[5] Although nonplaces might be filled with people, within them the individual's primary experience is one of isolation. Without the texture and friction provided by human agents inscribing a place with meaning, the nonplace becomes all background with no significant foreground action, like a stage set filled with extras. With this in mind, the disappearance of people from the public places depicted in the exhibition—the absence of passengers in Birgfeld's airport triptychs, of guests in Joy Episalla's photograph of a hotel hallway, of cars and people in Daniel Mirer's photographs of parking lots and hotels, and of workers in Won Ju Lim's cityscapes—can be seen as symptomatic of the diminishing relevance of the human to built space today. With this in mind, the sensation of "flying, floating, and (secretly) flirting with death" that Eno described may have as much to do with the traveler's passive engagement with the environment and feelings of irrelevance as it does with fears of an aviation disaster.

In his essay "The Unreconstructed Subject of the Contemporary City," Albert Pope describes contemporary urbanity as a condition

4. Marc Augé. *Non-places: Introduction to an Anthropology of Supermodernity*, trans. John Howe (New York: Verso, 1995), 86.

5. Augé, *Non-places*, 87.

38
VANISHING POINTS

wherein "the market has thrived, [but] the substance of a recognizably human city has been surrendered." The terms of this surrender, Pope explains, "imply the loss of a city in which we may perceive ourselves, in which we are literally constituted as subjects in the city's form and space."[6] This postanthropocentric urban landscape, Pope tells us, encompasses "the fantastic residue of the last fifty years of urban construction—the vast parking lots, zones of urban blight, urban expressways, corporate plazas; the *cordon sanitaire* surrounding office parks, theme parks, and shopping malls; the unkempt surroundings of massive slab cities; the endless, ubiquitous extent of corporate housing tracts; the entire collapse of inner-city development."[7] The city now addresses the individual only in his or her capacity as a consumer without regard to organic, human needs.

Nonplaces such as these make up an increasingly large percentage of our built environment. Impermeable, enclosed, artificially lit, and often active twenty-four hours a day, they are spaces in which a number of dialectically held oppositions—between the diurnal and nocturnal, consciousness and unconscious, real and artificial, body and environment—suddenly become untenable. The disembodied urban perspectives seen throughout *Vanishing Point* therefore attest not to the body's literal disappearance from public space but rather to the fact that the truly "public" aspects of that space are rapidly disappearing. In nonplaces, we become what our surroundings dictate: we are functions of the environment and ultimately incidental to it. That wouldn't be so troubling if these types of places were only intermittently encountered. The problem, these works seem to be telling us, is that nonplaces are rapidly consuming spaces that were once authentically public.

When architectural design loses the human agent as its referent, the urban environment becomes voracious, all-encompassing, and inhumane. This is the argument put forth in Jacques Tati's 1967 film *Playtime*. Shot in 70 mm and featuring an enormous International Style stage set built to scale specifically for the project—a stand-in for Paris dubbed "Tativille" by the film's cast and crew—*Playtime* is at once a spectacle of film technology and a profoundly humanist depiction of the modern city as monstrosity. In it, we see the once-

DANIEL MIRER
"Lobby at 9 West 57th Street, New York," 2002-3
Chromogenic print mounted on aluminium
30 × 40 in.
Courtesy of Rebecca Ibel Gallery, Columbus OH, and Priska C. Juschka Fine Art, New York

6. Albert Pope, "The Unreconstructed Subject of the Contemporary City," in *Slow Space*, eds. Michael Bell and Sze Tsung Leong (New York: The Monacelli Press, 1998), 162.

7. Pope, "The Unreconstructed Subject," 168.

familiar paths and byways of Paris replaced with vertical columns of mirror and glass. For Monsieur Hulot, the film's everyman hero and Tati's filmic alter ego, this translucent architecture presents a series of Miesian booby traps that he must somehow learn to navigate. The film also follows a group of American tourists traveling on "Economic Airlines" as part of a packaged vacation whose itinerary includes a visit to one European capital per day. After arriving at Orly airport in Paris, they find that it looks exactly the same as the previous airport in Rome, that the roads taken by their tour bus resemble those in Hamburg, and that the street lamps along those roads remind them of the street lamps in New York. Tati's joke is that as the tour group "progresses" from city to city, the set remains exactly the same.

The American tourists spend some time wandering through an exposition in one of the dozens of identical glass high-rises they pass through on their tour of modern Paris. This expo—a kind of temporary shopping mall—features rows of vendors selling eyeglasses, scarves, door panels, and other consumer goods. A parallel narrative in the film follows the sweetly hapless Monsieur Hulot who has been forced to become a tourist in his own city as he searches among the high-rises for a man with whom he has an appointment. Hulot's Paris is the older Paris of close-knit neighborhoods, not this dizzying crystal matrix. As he wanders, umbrella in hand, through endless lobbies, past rows of cubicles, and into yet more glass waiting rooms, Hulot appears as just another isolated and confused traveler who is finding it increasingly difficult to negotiate the harshly angled geometries of his surroundings or gain the attention of anyone around him, so lost is everyone in their own pursuits. The harried male secretary of the man with whom M. Hulot has an appointment constantly forgets about him; a beautiful young woman in the tour group returns his smiles and even accepts his small gift, but Hulot still has little opportunity to talk to her as her group is hustled back into the bus for its next stop.

The director furthers the sense of displacement by pitting his characters' bodies against the surrounding architecture. "For the entire beginning of *Playtime* I directed people so that they are following the guidelines of the architects," Tati once explained. "Everyone operates at right angles to the décor, people feel trapped by it."[8] Bodies are encased like butterflies in glass, their likenesses frozen within transparent doors and walls. When encountered they appear as reflected images rather than flesh-and-blood beings. In this pristine, antihuman environment, moments of actual contact between the body and the building become grotesquely exaggerated comic

8. This and all subsequent quotations from Jacques Tati are taken from Tativille, the official web site of Tati's films, http://www.tativille.com/.

moments, as in the scene where Hulot's umbrella clatters noisily onto the slick lobby floor, and, moments later, his backside bounces against the taut leather seat of a Breuer chair making a sound like a rattling drum.

As *Playtime* moves into its beguiling second half, its characters' experience of the city begins to change. Spaces that were once sharp, hard, and unyielding literally begin to soften. For one reason or another, all of the characters find themselves in a fancy restaurant on its opening night, unaware that this sleek and expensive establishment is not quite ready for prime time. The place is packed with customers, but behind the scenes things are falling apart. The new building's physical structure is shoddy; the fancy dining chair backs shaped like a pointed crown (the restaurant's logo) are leaving absurd-looking brands on the patrons' skin and clothing. Worst of all, the air conditioning has stopped working, and the patrons are starting to sweat. A band begins to play, and people start dancing, and continue to dance some more. Strangers begin to joke with each other about the heat. As the walls literally begin to tumble down around them, the guests begin to introduce themselves to each other. They dance, drink, flirt, play the piano, sing, and find each other in the process.

"Little by little, the warmth, the contact, the friendship, the individual that I am trying to defend begin to take precedence over this international décor," said Tati of this sequence. "It's at this point that the illuminated advertising begins to appear, things begin to whirl then to dance before ending in a veritable merry-go-round. No more right angles…." Significantly it is a broken air conditioner that is at the root of this change. When it breaks, so too is ruptured a certain subtle control of the body that the space had formerly maintained. As a result, the room heats up. Skin begins to stick to chairs. People begin to get drunk and to sweat and start to lose themselves and their inhibitions in the emotional and physical pleasure of each other's company. Everything begins to melt together into something more organic—and far more pleasurable—than anything the restaurant's designers could have imagined.

Tati's film ends on a deeply hopeful note, yet sadly it is the air-conditioned anonymity of the film's first half that has become more common than the sweaty camaraderie characterizing its final scenes. Almost two decades after *Playtime* premiered, Fredric Jameson

offered a compelling theoretical account of the interiorized, hyperdesigned world that *Playtime* presciently envisioned. In his essay "The Cultural Logic of Late Capitalism," Jameson describes the John Portman-designed Bonaventure Hotel (1974–76) in downtown Los Angeles, sketching the development of a historically new type of space whose contours were then only just beginning to be apprehended.[9] Jameson speaks from a position not unlike that of the bumbling Hulot, wandering through the hotel's circuitous lobby and walkways. Jameson struggles to maintain his sense of equilibrium, distracted as he is by the relentless up-and-down motion of elevators and the fact that the hotel seems to have no exits or entrances. He postulates that his own sense of disorientation must be the direct result of a "mutation in the built environment" out of which arises a kind of steroidal hyperspace—one that is always attempting to expand its boundaries, that "aspires to being a total space, a complete world, a kind of miniature city." Jameson concludes that "ideally the mini city of Portman's Bonaventure ought not to have entrances at all, since the entryway is always the seam that links the building to the rest of the city that surrounds it: for it does not wish to be a part of the city but rather its equivalent and replacement or substitute."[10]

Originally published in the 1980s, Jameson's evaluation of the Bonaventure remains relevant. Whether designed by architects or retail developers, contemporary built space is becoming at once more immersive and more isolating. Today we find fewer and fewer avenues of escape from these interminable, impermeable interiors, whose structures mimic that of the city plan while simultaneously anesthetizing it. In their attempts to provide virtual alternatives to the rawness of urban street life, developers often succeed only in bottling up all of the city's remaining open spaces. Hotels, planned communities, megamalls, and themed entertainment centers often seem like small-scale cities containing everything you need, but their ambitious and comprehensive scale creates a kind of hermetic urbanism in which inside and outside, day and night, and natural and artificial are growing harder to distinguish.

As we consume and are consumed by this environment, it is easy to feel lost within its dreamlike wash of images and steady hum of sound. This dizzying conflation of body and built space can be

9. This and subsequent quotations from Jameson are taken from "The Cultural Logic of Late Capitalism" (1984) in *Postmodernism, or, The Cultural Logic of Late Capitalism*, (Durham: Duke University Press, 1991), 1–54.

10. Jameson, "The Cultural Logic of Late Capitalism," 38–41.

usefully compared to the chameleonic ability of certain animals to camouflage themselves within their immediate environment. In his essay "Mimicry and Legendary Psychaesthenia," the French essayist Roger Caillois argues that the strategies of mimicry exhibited by various plant, animal, and insect species can be usefully understood as spatioperceptual disorders rather than as defense mechanisms. These disorders are characterized by a process of "depersonalization through assimilation into space" resulting from the confusion of real and represented spaces—essentially, a loss of boundaries between the organism and its surrounding environment. Caillois' theories of psychaesthenia therefore offer another useful framework for understanding the peculiar absence of the body from contemporary depictions of public space.

Playtime presents a number of comic bits that make the case for a kind of urban psychaesthenia that affects human beings, as when, unbeknownst to them, the men and women in the restaurant are stamped with the logos on their fancy chairs, or when Hulot mistakes the reflected image of someone in a glass window for the man himself. As Caillois explains, for psychaesthenic subjects:

> *space seems to constitute a will to devour. Space chases, entraps, and digests them in a huge process of phagocytosis. Then, it ultimately takes their place. The body and mind thereupon become dissociated; the subject crosses the boundary of his own skin and stands outside of his senses. He tries to see himself, from some point in space. He feels that he is turning into space himself—dark space into which things cannot be put.*[11]

Under such conditions the body/organism is virtually indistinguishable from the space surrounding it. It is as if the body is dissolving into space or even disappearing altogether.

Jonah Freeman's films are inspired by the types of sprawling city-within-a-city developments that Portman's Bonaventure Hotel represents. In these types of building environments, natural light is almost entirely eradicated while artificial lighting keeps spaces illuminated twenty-four hours a day. During his experience of such places in the past, Freeman notes, "I became aware of a specific feeling of displacement or disconnection from exterior space. The dialogue or relationship between inside and outside was becoming more faint. The scale of the architectural interior seemed to be altering my sense of time, light and natural cycles. I began to perceive all environments as stage sets where specific moods and fantasies were always being imposed. Even when I was in so-called 'nature' I felt as though I was on the outside looking through a ste-

11. Roger Caillois, "Mimicry and Legendary Psychaesthenia" (1935) in *The Edge of Surrealism: A Roger Caillois Reader*, ed. Claudine Frank (Durham and London: Duke University Press, 2003), 100.

44
VANISHING POINTS

reopticon at an imaginary vista."[12] Freeman's description of these "interior landscapes," to borrow Fabian Birgfeld's term, is one where the possibilities of human agency and social interaction are heavily circumscribed by the dictates of the built environment. There is something deadening about the places we see in Freeman's films. They are like theater backdrops before which people play out predetermined roles. So carefully fabricated are these nonplaces that they tend to call everything we consider natural into question.

Freeman's video *In and Out* (2001) depicts a sprawling luxury hotel complex (of the sort that often hosts conventions and other large groups) through a relentlessly moving camera that prowls the hallways, lobbies, elevators, and escalators. Another film, the 56-minute *The Franklin Abraham* (2004), is set within a mall-like fictional city of the future: a gargantuan agglomeration of interconnected structures that comprises residential, retail, and industrial spaces, plus government offices and various entertainment complexes, all within an enclosed environment that is a mile-and-a-half wide, two-miles long, and 150-stories tall. Freeman has invented an entire mythology around a building that pivots between place and nonplace. Now inhabited by some two million people from a range of social classes, races, ethnicities, and political interests, the Franklin Abraham was built haphazardly over two hundred years and without reference to any sort of master plan, and as such it can be seen as a figure for the "incoherent and incongruent" spatial conditions not only of sprawl and exurbia but of globalization itself. The structure's warrenlike layout is impossible to represent in full; viewers are given glimpses of parts of it as the film follows the storylines of various individuals whose glassy eyes, disaffected speech, and listless movements suggest that life within the Franklin Abraham, despite its many options, is unaccountably dull. Everything takes place indoors. There is no sunlight, only artificial illumination. The camera stays with one or two characters for a brief period of time and then moves on to follow someone else, never lingering long enough for audiences to become deeply invested in them.

Deborah Stratman's film *In Order Not to Be Here* (2002) offers a complementary vision of human-built sprawl, but in this case there are no humans at all. Structured mainly by a series of long static shots of parking lots, drive-thrus, single-family dwellings and gated entryways, the film takes us on a discomfiting tour of suburbia at night, when its inhabitants are generally assumed to be most vulnerable to attack. Throughout most of the film, the viewer assumes the disembodied (and dehumanizing) viewpoint of a static security camera trained on a series of empty lots. The fact that nobody is

WON JU LIM
"California Dreamin," 2002
Foamcore board, plexiglass, lamp, DVD projection, still image projection; dimensions variable.
Courtesy of the artist and Patrick Painter Inc., Santa Monica

12. This and subsequent quotations from Jonah Freeman are taken from his artist's statement for *The Franklin Abraham*, e-mail to author, July 26, 2004.

there leads us to ask: who, or what, are we so afraid of? Could it be these bleak, fortresslike enclaves themselves, and the growing sense of power and control they exert over us? In Stratman's film as in Freeman's, buildings and other forms of urban construction take on a looming, even threatening presence. People seem inconsequential, as if they are functions of the space rather than the other way around. Indeed the only real characters in Freeman and Stratman's films are the buildings themselves.

In many ways Won Ju Lim's *Elysian Field* (2001) could be a three-dimensional realization of Freeman's Franklin Abraham—a gorgeous monstrosity and a compelling model of the dense and dizzying type of space that the nonplace represents. Utilizing projected lights and films, Lim's sculptural installation renders the city as a type of dream space that exists in the subject's mind as much as it does material reality. Enveloping viewers in a theater of projected images, shadows, and refracted illumination, *Elysian Field* figures contemporary urbanism as a phantasmagoric experience where image is all. Lim's installation incorporates film footage of a Southern California oil refinery at night—which from a distance resembles the kind of all-encompassing future city imaged in Fritz Lang's *Metropolis* (1927), Jean-Luc Godard's *Alphaville* (1965), or Ridley Scott's *Blade Runner* (1982). Like a movie set, this oil refinery exists for people mostly as an image. Difficult to access on foot, it assumes its most spectacular and cinematic qualities only at night for viewers driving past in a car, when it appears as a brilliantly glowing, ghostly phantasm.

In contrast to the self-enclosed spaces that we have been discussing, Lim's Elysium can only be encountered as a backdrop. It is an alluring spectacle that seems to invite you in and embrace you, yet you can never enter it. This makes *Elysian Field* an essentially cinematic space, in part because it is dependent on darkness to work its magic. Viewers of the installation experience the projected background and footlights aimed at the sculpture as an enveloping, even overwhelming atmospheric condition that simultaneously magnifies and dissolves the hard solidity of the cityscape below. In Elysium, the urban realm has lost all borders and edges, becoming so intensely atmospheric that it verges on the purely imaginary. Here, reflections are confused with real objects, materiality and illusion compete for our attention, and all that is solid has indeed melted into air.

Night, the inherently theatrical setting of Stratman's film and Lim's installation, as well as works by e-Xplo, Amy Wheeler, and other

artists in *Vanishing Point*, might be another manifestation of Roger Caillois' *"dark space into which things cannot be put."* It offers yet another form of nonplace, another type of background into which foreground elements dissolve. Night in many ways is the ultimate vanishing point, allowing figures to recede into the shadows or otherwise disappear from view. In these artists' works it presents itself as a kind of reverse-space or negative image that reveals new information by concealing the familiar from us. While we associate consciousness with clarity and light, night is a trope for the hidden, for the subconscious and unconscious mind. Fear of the dark, Caillois suggests, derives from the frightening inability to perceive potential threats when they are blanketed in darkness. For Caillois darkness is palpable. It is "'thick'; it directly touches a person, enfolds, penetrates, and even passes through him." Darkness blurs boundaries between outside/inside, body/environment, which may account for the aura of mystery and unease so often attributed to the nocturnal hours. Caillois goes on to argue that the assimilation of the body into dark space "is inevitably accompanied by a diminished sense of personality and vitality."[13]

Although it may be an exaggeration to say that the depopulated nonplace (whether visited by day or by night) represents the future of all public space, the nonplace is colonizing a larger and larger portion of our shared environment. It is important to remember, however, that place and nonplace are relational rather than purely oppositional terms for mapping the fluid territory of space and subjectivity, architecture and human action. This means that place can reconstitute itself in nonplace, and vice versa. The works in *Vanishing Point* collectively describe a world in which humans seem to have evacuated the scene. Within these depictions human presence is reasserted through a persistently felt subjectivity that lies outside of the picture plane, mirroring the disembodied perceptions of Caillois' psychaesthenic organisms. The space of this absent, authoring vantage point is occupied by the artists, of course, whose works chronicle the vanishing human along with a diminishing social body. But even more significantly, this space is embodied by you and me as both the viewers and the subjects of this work. When we stand before these depictions of empty spaces and placeless places, we bear witness to the disappearance in question: a disappearance that is, ultimately, our own.

13. Caillois, "Mimicry and Legendary Psychaesthenia," 101.

BRADON LATTU
Miracle Mile, Looking West, Pedestrian View, detail.

Ken Ehrlich

THE ARCHITECTURAL SIGN: LOS ANGELES IN BUILDINGS AND WORDS

The contemporary conflation of signage and architecture has a confused history. It's a story that must be puzzled out, less to come to an absolute understanding of how buildings' labels function than to put the discourse emerging between art and architecture in context. A generation of Pop artists honed in on the theme and visually speculated on the relationships between signs, buildings and the built environment. In particular, the vast body of work by Ed Ruscha, whose gaze has been focused on signs since the 1950's, draws attention to the aesthetic relationships between buildings and signs, between architectural structures and semiotic ones. The architects who most forcefully inserted the importance of the blurring of signage and architecture into post-modern architectural discourse (and arguably into post-modern discourse in general) were Robert Venturi, Denise Scott Brown and Steve Izenour in their now canonized text, Learning from Las Vegas. In 1972 Venturi et al. described a kind of "populist" vernacular architecture—in the form of cheaply built structures that communicate through blunt signs—as an invitation to consider the slippery dynamics between a building's self-promotion and patterns within the built environment in general; an effusive celebration of the collapse between forms of marketing and the shape of cities that now appears both prescient and somewhat dulled as meaningful critique. The impulse, in Learning From Las Vegas, to disrupt the purism associated with Modern Architecture served as an important challenge to the failings of the Modern movement, but it has arguably contributed to a contemporary discourse located somewhere between art and architecture that confuses irreverence and the "fusing of high and low" with a presumed radicality, as if, by taking cues from the crass materialism projected throughout the built environment, an artistic or architectural project might manage to send a flip message to the "cultural elite," via some form of responsible populism. If Venturi et al. originally sought to radicalize architecture by looking to the most banal forms of commercial buildings and their signs for inspiration, thirty years after Las Vegas was imagined to be a prescriptive architectural landscape of image and surface, what can be made of the continued collapse of buildings and signs? How can contemporary artists' preoccupation with architectural tropes be understood in relation to Venturi's legacy? Whereas in 1972, looking to forms of popular architecture might have been considered somehow disruptive to the normative structures of cultural production, cultivating a receptive and yet critical relationship to the visual collapse of signage and architecture now demands a re-tooled syntax, a re-structured response, a reflection less ironic…a rhetorical renovation of the existing cityscape rather than a continued celebration without reservation.

The contemporary collapse of architecture and signs is visible all over the streets of Los Angeles. After all that has been said of L.A. architecture, notably the mythological brief life-span of most buildings here and the much discussed sprawling horizontality of the metropolis, the experience of observing the city outside of strictly residential neighborhoods is very often the experience of reading signage. The visual character of Los Angeles appears to have been designed, consciously or not, under Venturi, Scott Brown and Izennour's advisement. Aside from the obvious monumental architectural "landmarks," much of the built environment of the city corresponds precisely to the ordinary and blunt symbolism celebrated in *Learning from Las Vegas*. Most commercial architecture in Los Angeles completely ignores the "articulations of the pure architectural elements of space, structure, and program"[1] that have come to be associated with Modernist Architecture; instead the redundant rows of mini-malls cultivate an architectural language trapped between a cynical admission of the failure of Modernist utopianism and post-modernism's playfully irreverent pastiche. What kinds of meaning can be derived from the endless commercial architecture of Los Angeles, the boring stucco boxes with deadpan signs plastered to their façades flatly describing the building's function? What of interest might possibly be dredged from the most uninteresting buildings in the city? Following Venturi's insistence on an analysis that begins with what exists rather than idealized versions of the city, I'm convinced the signage of the city might function as a kind of projection screen to reanimate the space of the city as neither subject or object, as a site to lodge artful conspiracy theories about spatiality and to encourage the kind of productive spacing out that happens when staring at a sea of signs…

By signs here I am referring primarily to the architectural signs that describe a business's function. For though we might differentiate between a billboard and a sign for a restaurant, the structure of the advertising landscape in Los Angeles cannot be considered entirely distinct from the architecture of the city. Billboards jut out of and dwarf buildings. High-rise facades are themselves surfaces used to broadcast consumer messages. Where the building ends and the sign begins is a blurry boundary subject to slippery codes both tangible and repressed. How do we read the signs of the city? As image or text? As language or as marks in the code of a visual aesthetic? Or in some difficult combination of all of the above?

Of course, the word sign itself has various connotations and it might be useful to consider the linguistic function of the architectural sign in all of its apparent forms. Like Venturi, Umberto Eco distinguishes between the connotative and the denotative functions of architectural signs. He suggests that buildings carry communicative meanings that are related to but also exceed a building's function. In this murky terrain of *signs* and signage the communicative language that fronts as building facade is related to a building's function only in that buildings stand as signs to be read. The confusion between buildings and signs extends through a semiotic relationship and into the realm of the city.

Eco suggests that architecture can be considered a form of mass culture, "and as a communicative operation directed towards large groups of people and confirming widely subscribed to attitudes and ways of life while meeting their expectations, it could certainly be called mass communications loosely, without bothering about any detailed criteria."[2] Eco then proceeds in great detail to describe the ways architecture has "characteristics in common with the messages of mass communication." Of these characteristics, there are two in particular that are especially relevant thirty years after the text was originally written. First, he suggests that architecture "fluctuates between being rather coercive, implying that you will live in such and such a way with it, and rather indifferent, letting you use it as you see fit."[3] This double life of architecture in general—as an almost oppressive structuring device in the daily lives of say, the residents of Los Angeles in 2006, and a nearly silent backdrop for the uses and misuses of the city—creates a tension in the way that the architectural sign might be read. We are assaulted by an array of signs that, however forcefully they insist upon a certain reading, can always be misread, re-arranged, and whose meanings slip and shift.

Eco secondly proposes that "Architecture belongs to the realm of everyday life, just like pop music and most ready-to-wear clothing, instead of being set apart like 'serious' music and high fashion."[4] If, following Eco, we consider architecture not as a distant object to be studied but as a changing element in the sloppy business of daily life, to contemplate the sign in Los Angeles is to bring attention to the interconnected minutiae of the city. Everyday life does not occur in isolation from architecture. If Eco seems to be valorizing the 'low' in the high-low equation, it is in a less prescriptive mode (with an admittedly significantly smaller impact) than Venturi's celebration of Las Vegas. Eco seems to be suggesting instead that the 'realm of everyday life' is not something upon which to build a model, rather it is an ongoing event that might draw attention to over-looked details, glossed over histories, and overly formalized formations.

We must arrive at the theory of art by means of a detour.
— JOHN DEWEY

Searching for ways to address questions around the reception of art, artists since the 1960's have looked to the space between art and architecture as a potential tool to activate forms of participation—either literally or more subtly—on the part of art audiences. Pamela Lee summarizes this art historical trajectory by linking the subtractive, explicitly architectural work of Gordon Matta-Clark with the work of artists like Michael Asher, Daniel

star
fastener
strip
service
custom
hitches
cutting
balancing
vintage
freeze
metal
glass
die
donuts
produce
bargain

1. Robert Verturi, Denise-Scott Brown, and Steven Izenour. *Learning From Las Vegas* (Cambridge: MIT Press, 1972), 103. Also see Venturi and Brown. *Architecture as Signs and Systems: For a Mannerist Time* (Cambridge: Harvard University Press, 2004).

2. Umberto Eco, "Function and Sign: The Semiotics of Architecture," in *Rethinking Architecture*, ed. Neil Leach (London: Routledge, 1997), 195.

3. Ibid., 196.

4. Ibid.

Buren, Dan Graham, and Hans Haake. The work of these artists, Lee suggests, "reflects upon the maintenance and evaluation of the work of art though the channels of its distribution—or, in specific instances, the ideological interface between art and the institutions in which it circulates."[5] It seems that in the work of these artists, an active examination of the architecture that houses art becomes, in its own right, an artistic practice. "It makes plain that the museum and gallery, as particularized manifestations of the social relation, participate in shaping the reception of the work of art through a dense if often imperceptible weave of political, cultural, and economic interests. Often, the peculiar architectural character of these places is addressed, as if to convey the value architectural space accords to its objects."[6] Following this thinking, contemporary experiments at the intersection of art and architecture are not only about raiding the formal tropes of each discipline to further a narrow agenda in the other. When viewed historically as part of ongoing discourses about various models of reception, the presence of architectural vocabularies in visual art continues to hold critical potential.

Of the contemporary art discourses wrestling with notions of reception, many seem to contend with the notion of a "relational" model. Critically challenging the writing of Michael Fried, Grant Kester, for example, speculates about a dialogical 'third way' of understanding or receiving the work of art. Traditional art criticism often suggests art is viewed either formally or rhetorically and historically. From a Modern perspective, when apprehending a work of art, the viewer is given essentially two options. If a work of art is successful, according to this logic, it is apprehended instantaneously and intuitively and not critically or rhetorically. If a work of art solicits a critical response in the viewer that encourages a historical or linguistic reading, the work has failed. This version of formalist art criticism associated with Fried has been seriously challenged since his writings appeared in the mid-sixties and in fact provoked strong critical reactions at that times as seen in the writings of artists like Robert Morris. For Kester, like so many of Fried's critics, the mythological apprehension of a work of art made possible from an intuitive instant is flawed precisely because it fails to acknowledge the very historical and linguistic structures that precondition such a moment were it ever to happen. Kester's dialogical model is informed by a strain of community-based artworks in which the autonomous artist's expressive or aesthetic will is subordinate to an engagement with social structures, institutional systems, and notions of communication, intervention, discussion, and participation. He proposes that "the work of art can enact community here and now through the process of physical and dialogical interaction."[7]

In Kester's analysis, an active and dialogical relationship within a specific set of parameters allows artists bent on reconsidering the presumed passivity of most art audiences the opportunity to create community through a relational form of advanced art. The examples he uses are artists and artist

groups whose practices might not be recognizable as art to most audiences, including Helen and Newton Harrison, Stephen Willats, and WochenKlausur among others. Kester seems intent on granting legitimacy to community-based art projects by reading the work of these artists through a rigorous art historical lens. There is certainly a critical value in bringing attention to neglected forms that rightfully belong to the sphere of contemporary art practice and to those that seek to expand the limits of what can be defined as art. Is there, however, some way that this dialogical model can itself be extended beyond the arena of community-based work and gently nudged in the direction of a reading of contemporary art works that display tropes typically associated with more "conventional" artistic strategies? That is, in creating works that are neither explicitly community-based nor reliant entirely on the formal vocabulary of recent art history, can artists meaningfully provoke questions about the role of the work of art?

If community-based artworks are motivated, at least in part, by the sense that often artistic production takes place in isolation from the direct lives of nearby communities, the question arises: How do we define community? The relative insularity of many artistic communities in Los Angeles is self-evident and at the same time, many so-called community-based art works fail to interrogate the notion of "community" itself. The fragmented nature of the myriad diverse artistic "communities" in Los Angeles seems reflective of the very marked fragmentation of the city's communities. Approaching the collapse of signage and architecture in the city artistically might indicate a perverse attempt to grapple with the fundamentally fractured city in which community is more an abstraction than a reality. In this way, the artwork might fluctuate between a highly abstract yet "documentary" view of the city and an object that itself refers back to the lived experience of the city without mythologizing the lives of a so-called community. Can we imagine a dialogical view that points in the direction of a historically contingent, critically engaged looking that does not reify the object being looked at? That is, can we engage the sea of signs encountered in the space of the city in a dialogical way and can a photograph, an artwork or a book, or even an essay not simply reproduce the familiar signs each might display?

Published in 2005, a monograph of the work of the artist Brandon Lattu, *Selected Works 1996-2002*, wrestles with these very questions. In particular, two projects presented in the book deal explicitly with the city of Los Angeles as primary subject matter. *Miracle Mile* (2000) is a monumental series of five images that present views of the illuminated signs visible on Wilshire Boulevard at night. The images reproduced in the monograph, originally nearly four by four-foot photographic prints, are striking at first glance because of the absence of any details other than the signs. The vast majority of the surface of the images is an expansive field of black. A curious flattening of space is also at work. Any expected perspectival views are exchanged for a collaged presentation of the signs scaled in relationship to one another and in relation to

5. Pamela M. Lee. *The Object to be Destroyed: The Work of Gordon Matta-Clark* (Cambridge: MIT Press, 1999), 87.

6. Ibid.

7. Grant Kester. *Conversation Pieces: Community and Communication in Modern Art* (Berkeley and Los Angeles: U.C. Press, 2004), 58.

a presumed viewer. Through this meticulous technical re-ordering of the streetscape and the superimposition of a rigorous conceptual system to produce images of the Miracle Mile, Lattu erases any trace of people, cars, buildings and indeed activity.

In contemplating these images, the viewer is submerged in a compressed spatial relationship with the commercial rhetoric of signs. The landscape of the *Miracle Mile* is a world completely dominated by branding. Each of the buildings' signs displays a highly refined aesthetic and communicates a highly abstract image of a particular business or service. In this imagistic collapse, the arbitrary nature of the sign spills over. The brands fuse transparently but aggressively into each other and the carefully constructed corporate identity of each is set in relief; as if when all the logos are forced onto equal footing the desire to create a fixed, or branded, corporate identity is unmasked and the images become persistently unmoored from their specificity. It's less that the logic of corporate identity loses its meaning, but when the intense nurturing and cultivation of specific meanings becomes so clearly evident, the signs themselves are rendered both completely transparent and increasingly obtuse. While only partially readable, they are yet somehow ultimately in a position to say more. The visual non-sense in Lattu's images beg the questions…In the face of an overwhelming sea of signs, is there any longer sense in a "sensible" sensibility (have I granted legitimacy to an oppressive rationality by trying to argue legibly)? How does one sensibly respond to a sense of semiotic overload?

How does one retain sensitivity to the nuanced sense of signs at work in Lattu's project rather than digesting the pre-packaged sensibility of the corporate sign?

As important as the signs in *Miracle Mile* are the fields of black. Like a cinematic void or a perverse conflation of a monochromatic painting with some Pop insertions, dense black surfaces dominate the frame of the images. The density of the black absorbs all the potential excess color from the images and becomes home to a charged space of absence. The blackness here provides a respite from the visual overflow of the city…it gives the latitude to contemplate the blankness available within the signs themselves. Unlike a mythological blank white screen upon which free-floating fantasies are projected, this black field is a densely loaded space where the conflation of sign and image, word and color, scale and perspective enunciate formally. This formalism is not transcendent, however. It is precisely *through* this layered, commercial landscape that we might see in the signs something other than the banal, functionalist banner they were meant to be.

Film Without End, Lattu's ongoing video project begun in 1999 and also documented in the monograph, has a more explicit relationship to questions of everyday life. Again employing a highly structured conceptual model, Lattu keeps a record of every road he drives in his day-to-day life in Los Angeles. Retracing his routes at night and projecting a blank slide out of the car window, he has shot over thirty hours of footage that presents a rectangle of light bouncing and dancing across the built environment. The smaller, white frame of the slide seen within the larger darkened frame of the video screen illuminates fleeting fragments of the city

as they flash across the screen. This blank frame of light projected onto the city clearly presents a view of Los Angeles distinct from the highly stylized film images produced by and for Hollywood. The unavoidable reference to the rather banal landscape that surrounds the cultural mechanism that exports cinematic images to the world is present in the work, but the video seems less a critique of Hollywood than an investigation of seriality and by extension the passage of time and the nature of memories. Like the endless hum of traffic on so many L.A. freeways, the video is relentless but not without rhythm. But unlike the movement in the city the video is absent a soundtrack. The silent video creates a time-based collage in which buildings, signs, and the passing landscape are simultaneously foreground and background.

The unending status of the video referred to in the title of the piece addresses both the artists' continuous navigation of unfamiliar parts of the city and the seemingly endless visual landscape of the city itself. In treating the optical experience of gazing out of a car window as a potentially never-ending process, Lattu relates the temporal quality inherent in video to the (slowly) changing terrain of the city. In turning to the architectural face of the city as the source material for this work, *Film Without End* situates the formal aspects of the city's identity as historically contingent. Buildings evolve. Aesthetics shift. Without creating a hierarchy of taste, the video documents the radical diversity of buildings and signs in the city as itself a process. The process of the city's evolution seems to have a life of its own and at the same time is intimately connected to the lives of the inhabitants of the city. By returning to streets Lattu travels for reasons unrelated to the production of the video, he draws the viewer's attention to the architectural details that might be overlooked in everyday life.

A sampling of video stills are reproduced in the monograph, seen as rather dark images containing the illuminated frame of the slide projector. The images isolate and fragment architectural details. In one image from Santa Monica Blvd., a portion of a colorful series of letters painted onto a column is highlighted. It at first appears that an arbitrary element of the building and its sign have been isolated. On further reflection, it becomes apparent that this fragment reproduces photographically precisely the sort of distracted glimpse of an architectural detail one might perceive from a passing vehicle. What becomes of this kind of visual information we get in a state of distraction? the images seems to be asking. And in drawing attention to shards of visual information that quite possibly would otherwise be overlooked, *Film Without End* draws attention to the act of looking itself. In the work, the cinematic view of the city is reframed and refined. The viewer witnesses an onslaught of excruciating urban detail framed as ongoing movement.

union
balcony
join
fashion
collection
orange
photo
gift
international
county
university
state
clearance
mortgage
quality
used
new
hours

65
KEN EHRLICH

In *Starving for Embarrassing Architecture*, Berlin-based artist Erik Göngrich catalogs his research on the contemporary urban experience of Los Angeles. A publication consisting of photographs, drawings, and plans, this book was produced during a six month residency in the city in 2003. As a visitor Göngrich framed his project through a series of more than 40 interviews with artists, architects, planners, and others he conducted during his time in the city. The three questions he posed during interviews are variations of what is your favorite place in the city, what is the most horrible place in the city, and what is your ideal living/working space? Through these seemingly simplistic queries about individuals' idiosyncratic sense of urban and personal space, Göngrich is able to create a vast set of images that directly speaks to the socially constructed nature of the urban landscape.

In particular, Göngrich seems almost magnetically drawn to the Los Angeles version of perhaps the most common architectural form: the cube. In the publication, he methodically documents the city's love affair with the box. From the iconic fifties modernist version right up through the contemporary stucco affair, the box becomes emblematic of the kind of deadpan absurdity that can be

diner
first
care
health
system
building
agape
tailor
broiled eel
education
institute
post
caller
custom
florist
rental
midway
training
liberty
red
entrance
salad
sandwich
taxes
renting
cement
now
medical
theater
only
bowl
meet
offices
center
swap
metro
cellular
pupusas
month
tienda
beeper

found over and over again on the streets of Los Angeles. This truly is the box city. By juxtaposing photographs of endless architectural boxes against an image of a delicately stacked arrangement that reads "we sell boxes" in front of a business selling cardboard boxes or a playful drawing that reads "I love boxes," the hundreds of images in *Starving for Embarrassing Architecture* become a way to see the absolute surreality that is ever present in the city. The box slowly begins to read as a sign of the coercive similarity endemic to most southern California architecture and as a kind of vessel for endless variations on the theme. The variation and customization of the architectural box become as important as the seeming monotony of the form. *same same but different*, as the saying goes.

The artistic practice revealed in *Starving for Embarrassing Architecture* is an ambitious combination of seeking out the utopian impulses at work in the city and putting on display the dystopian and jarring scenes visible all over Los Angeles. A careful strategy of observation reveals in the streets of Los Angeles a series of images in which poverty and wealth, excess and desperation, and selfishness and generosity blend, seams exposed, into an asymmetrical pattern of failed urban planning and palpable desire. Göngrich presents the boxy architecture of the city as constructed by and implicated within the social dy-

namics at work in the city. The privatization of public space, the failure of public transportation, and the lack of real density all become glaringly if somewhat implicitly clear. In the midst of a city so clearly mis-managed, under-planned, and architecturally eclectic, the architectural sign stands as the semiotic mediator between the conflicting forces and impulses at work in the city. "Box city" describes a condition, labels a business, predicts a less than ideal future, and playfully signifies the potentially infinite variations the shape the city may come to inhabit.

Brandon Lattu and Erik Göngrich share little in the way of artistic practice or in the production of objects. What they have in common is an interest in the city as a place to fuse architectural, sculptural, photographic and semiotic questions. A highly abstract artistic process works alongside of an almost documentary practice in both of their close readings of the city of Los Angeles. And finally, and perhaps most significantly here, it is in the form of books that the works may be encountered. Both artists produce work that can be experienced in a variety of contexts but have chosen to actively seek out publication in the form of books. The book, like the city, becomes a space where images and text blend and conflict. The discourse that moves back and forth between architecture and art seems bound to the book.

Often it is in the space of the book that historical works of art are encountered, championed, and reflected upon. It is in the space of the book that ephemeral works of art intended to disrupt objectification, reification, and commodification are now reproduced over and over. Robert Morris points to this possible contradiction as early as 1978 in *The Present Tense of Space*, an essay devoted to the question of experiencing space seen through a historical relationship between architecture and sculpture. Describing the ephemeral works of artists whose efforts sought to produce an experience of space that "resists photography as its representation," Morris imagines photography as that thing which might "convert every visible aspect of the world into a static, consumable image."[8] Lattu and Göngrich, though both sensitive to the reductive nature of the photograph, do not share Morris' idealist notion of experiencing space entirely beyond the frame of the image. Instead, like others invested in critical discourses that move between art and architecture, they understand that *through* a rigorous image production, alternative ways of seeing the city are still possible.

latinos
enter
grand
chinese
dentist
loco
precios
familiar
smart
choice
thai
envios
breast
royal
viking
exam
beauty
benefit
private
slow
tires
care
coin
water
hot
laundry
video
frozen
inn
express
licensed
pollo
served
ostioneria
anyone
mechanic
plus
labeling
x-ray
brakes
value

8. Robert Morris. *Continuous Project Altered Daily: The Writings of Robert Morris* (Cambridge: MIT Press, 1995), 201-202.

united
sillas
stereo
quality
furniture
mercy
liquor
block
refinance
seguros
alegre
printing
beat
labor
shoe
church
wash
plomeria
market
ice
zone
drinking
tacos
station
plants
exquisite
cashed
express
carpet
storage
rebuilt
domestic
available
graphics
deli
managed
tavern
records
dental
embroidery
cut

BOXES ARE FUN

BOXES ARE USEFUL

68
THE ARCHITECTURAL SIGN

coupons
advance
coffee
family
nails
taste
burgers
path
cocktails
self
pastrami
burritos
clear
ice
nails
academy
college
products
radiators
valley
business
moon
textiles
dog
lincoln
factory
clinic
lotto
coin
open
everyday
way
save
dream
max
plus
esquina
accept
image
jumbo

GIFTS ARE WRAPPED IN BOXES

IMAGE: ERIK GÖNGRICH

69
KEN EHRLICH

1
1
2
3
5
8
13
21
34

Kathy Battista

LET THERE BE LIGHT

Light is symbolically associated with positive things: the light at the end of the tunnel, the light of hope, or angelic light. While darkness is the domain of demons, treachery and uncertainty, light is the force of goodness, cleanliness and order. Manichaeism has obsessed poets and artists as diverse as Milton, Blake, Shakespeare, Caravaggio and Turner. Where darkness represents earthbound, morbid heaviness, light is seen as ethereal and floating, weightless and timeless.[1]

Some of the most significant artists of the twentieth century have used light as material: from early experiments in optics by Man Ray and Marcel Duchamp to more contemporary works by Dan Flavin, Bruce Nauman, Maria Merz and more recently Martin Creed[2] and Tracey Emin, light and its materiality has been exploited, often in the form of neon. While associated with the urban environment and commercial spaces, neon has the unique characteristic of being able to be sculpted into a variety of forms, from script to pictorial graphics, lending to its visual appeal. Like a video installation, which is also dependent on a light source, neon works exist not only in the material itself, but the space around the piece. For example, a Flavin sculpture affects every inch of the site it occupies; the light emanating from the work allows the artist to defy the spatial limits of the wall or plinth on which it is shown.[3]

Two exhibitions in Europe, one temporary and one semi-permanent, use light as the starting point and inspiration: The Radiance Festival in Glasgow and the Center for International Light Art in Unna, Germany. Both exhibitions begin with the notion of light as a source for regeneration in the city; however, they achieve this in quite different ways. In Glasgow the use of light was dotted throughout the city in highly visible public interventions that took place over one weekend. In Unna light is the subject of a subterranean museum dedi-

1. There are, of course, all the racial connotations of light and dark as well. For discussions on light versus dark, and in particular white versus black, see: Richard Dyer, *White: Essays on Race and Culture*, London, Routledge, 1977; and John Tercier, ed, *Whiteness*, London, Lawrence & Wishart, 2000; Toni Morrison, *Playing in the Dark: Whiteness and the Literary Imagination*, New York, Picador, 1993.

2. Creed most famously exploited issues around light with his piece for the 2001 Turner Prize, *Turning the Lights On and Off*, in which he left the gallery completely empty, except for the alternating presence of light and dark.

3. As I write this piece a Flavin retrospective is currently travelling among various international venues. Opening at the National Gallery of Art in Washington the show will also travel to the Hayward Gallery and the Museum of Contemporary Art, Chicago in 2006.

cated to artists using this medium where all but one piece are completely obscured from the general public, located several meters underground.[4]

Glasgow and Unna, although quite different in size and location, were historically important centers of industry. Glasgow was a shipbuilding hub, with the Clyde River as a main hub of transportation. Unna was also a leading industrial city, located in the Ruhr district, which is now part of an industrial heritage tourism route. The Linden Brewery in Unna was one of the largest in the area, and an important source of employment. Its cellars were for many years defunct, and used occasionally for events. Like much of Glasgow's downtown, it is in need of revitalization.

In 2001 The Center for International Light Art opened as a museum inviting international artists to make site-specific work with light. Mario Merz, Keith Sonnier, François Morellet, Christina Kubisch and James Turrell are among those currently on show. Where Unna is a semi-permanent project, with installations lasting for long periods of time, Radiance took place over one weekend in late 2005: the 25th – 27th November. This project was instigated by the Glasgow City Council. Its visual arts projects were curated by Katrina Brown and managed by Gerrie van Noord (formerly of Artangel). Like Unna, it is international in scope, with participating artists ranging from the local—Ross Sinclair and Sans Façon—to artists from further flung parts of the globe, such as Ervin Çavasoglu from Turkey, Ceal Floyer from Great Britain and Adrian Paci from Albania.

While the Radiance festival and the light museum are completely different in duration and site, their strategies are similar. Both projects don't limit themselves to artists who traditionally work with light. Christian Boltanski, James Turrell, Olafur Eliasson and Mario Merz are often associated with this medium; however, the Centre for International Light Art also invited artists such as Joseph Kosuth to make work for Unna. Kosuth's installation, *Die Signatur Des Wortes (Licht Und Finsternis)* 2001, is the first one encountered in the museum. It is a neon text installed on the floor, viewed from above, on a series of zigzagging platforms. Because the room is ten meters high, it offers viewers a bird's eye-view of the piece, which contains a quotation (in German) from the poet Heinrich Heine:

> A man needs only to / express his thoughts / to create a world, / there is light or darkness, / the waters are / separated from the dry land, / even wild beasts appear. / The world bears / the stamp of the word.

Kosuth treats light as a bearer of text, typical of his conceptual, philosophically inspired, practice. Whereas Boltanski and Turrell's installations capitalize on the atmospheric and spectacular effects of lights, Kosuth sets a more serious tone with his installation.

Likewise, Olafur Eliasson's piece treats light in a unique way. Instead of using light in a "painterly" manner, the artist creates a charged environment. His *Der Reflektierende Korridor*,

4. The one exception is Mario Merz' piece Fibonacci-Reihe 2000, which is the famous mathematical series in neon on the smokestack of the brewery, which acts as a semaphore for the museum. The next phase of the museum is hoped to bring light above ground and dispersed throughout the town. See Maren Katrin Poppe, Zentrum Für Internationale Lichtkunst Unna, Cologne, Zentrum Für Internationale Lichtkunst, 2004.

... nur seinen ...
auszusprechen, und
es gestaltet sich die

ICH IK
ICH IK
ICH

LET THERE BE LIGHT

Entwurf Zum Stoppen Des Freien Falls 2002 occupies the fifth room in the museum. Eliasson created a corridor out of curtains of water in the dark subterranean room, which is lit only by a strobe light. The effect on the viewer is a dreamlike, atmospheric state where droplets of water seem suspended in the space. The additional element of sound (from the water falling) as well as the generator (powering the waterfalls) creates an overwhelming experience. Here the cavernous site is used to its maximum capacity: the dark, cold cellars of the brewery are the ideal location for such a work, which might prove challenging for a museum or gallery to present.

Perhaps one of the reasons that the Center for International Light Art is the only museum dedicated exclusively to this medium is its exceptional location and qualities.

Where the project in Unna capitalizes on its dank and somewhat fugitive brewery, Glasgow attempted to reinvigorate the city through light interventions. While visitors must arrange a tour of the Center for International Light Art, *Radiance* offered the opportunity to amble around the festival aimlessly or to view it as a walking tour of the Merchant City. One of the most innovative aspects of the project was that at times it was difficult to distinguish between the art and existing light of the city: neon signs mingled with works of art and jostled for attention.[5] Some of the work in *Radiance* played upon this confusion. Frank Scurti's *Les Reflets* series featured recognizable French signs, such as the green apothecary cross or the Lotto logo, rendered squiggly and in reverse. The only way to get a positive impression was to look at the reflection of the piece in the puddles in the street.

San Façon's intervention took the form of a double spotlight on Candleriggs, a street in the heart of Merchant City. At first glance it seems another example of the ambient streetlight found in any urban area. However, when the viewer walks into Limelight he/she is suddenly transformed into a player on the stage. Such a simple gesture seems almost furtive in its ability to resist yet contain spectacle.

One of the best aspects about *Radiance* is that it engaged with light in a variety of forms. In Unna, video is sadly lacking in their current set of installations. Radiance embraced video with works by Ceal Floyer, Gunilla Klingberg, Adrian Paci and Ervin Çavasoglu. Floyer showed her seminal piece Blind 1997 in a derelict shop

5. Further confusion was added by the intervention of an anonymous piece of work hung in an alleyway by a member of the public. Thanks to Gerrie van Noord for pointing this out to me. In this article I am concentrating on the visual art aspects of *Radiance*. There was also a programme of performances and events and architecture interventions led by nva, the lighting design agency based in Glasgow, which specializes in public art. See www.nva.org.uk

window, while Adrian Paci's poetic *Turn On* 2004, a hit at this year's Venice Biennale, was shown on the side of a building. This work, shot in his home town of Shkodra, Albania, shows a group of men who sit on public steps in the town square, each turning on a light generator. *Turn On* refers to Albania's inability to provide energy for the new domestic appliances from the West, which became available to its citizens after the fall of Communism.

If culture can be used as a strategy for urban regeneration, as Charles Landry[6] (among others) has written, both *Radiance* and the Center for International Light Art are interesting case studies of this phenomenon. They approach the task by different means: Glasgow through a highly visible public light festival aimed at a wide audience, Unna through a discreet museum with a fascinating history. Though artistically of merit and equally entertaining, what long-term impacts are they having on their respective cities? It is doubtful that either project will have the regenerating power of a museum like Tate Modern or Guggenheim Bilbao, both of which have led to the gentrification of their local areas. However, the Center for International Light Art and *Radiance* are compelling examples of attempts to re-energise dilapidated inner cities. In this respect, we might wonder if light functions as a metaphor for such regeneration. In whatever way they engage with visitors, either through guided tours or by walking past unaware, each makes a subtle impact on its environment. From optical phenomena to cultural connotation, both projects raise questions as to the role of light in our everyday culture, leading us to consider both streets and museums as particular sites for display.

6. See Charles Landry, *The Art of Regeneration: Urban Renewal Through Cultural Activity*, London, Demos, 1995.

SIMPARCH

DIRTY WATER INITIATIVE

INTRODUCTION BY JENNIFER GABRYS

Water has a high surface tension. Cohesive and elastic, in its liquid state, it binds together as a medium of transport and dilution. Increasingly, it is a medium of high surface tension with respect to availability. With the *Dirty Water Initiative* intervention in Tijuana, Mexico, the artists' collaborative SIMPARCH has delved into the social, economic and geographic issues that circulate through the medium of water. Installed at inSite_05 during later summer 2005, *Dirty Water Initiative*, like many of SIMPARCH's projects, operates on the border of architecture and popular culture. SIMPARCH explores how home-brew, D.I.Y. constructions can provide fresh ideas within difficult cultural and political terrain. At once elemental and political, SIMPARCH's *Dirty Water Initiative* brings to light the growing dilemma of water, which is polluted, scarce, bottled, privatized, and wasted. Their intervention, which consists of a passive solar-powered water purification system installed in a central plaza in Tijuana, interrupts the politics of water flow and puts this most basic of resources back into the hands of the people.

Water, the "universal solvent," not only enables life but has often been the basis for the location of major settlements. Rivers and seas are the sites where ancient and contemporary cities have been established and flourish. Yet for this same reason, these major sources of water are often subject to contamination and conflict. Factory spills can destroy the water resources for entire cities, as evidenced by the recent Benzene spill in the Songhua River in China. In highly populated areas people's day-to-day ingesting and expelling can also contribute to strange substances in the water. Residues of pharmaceuticals such as Prozac have been found in the drinking water in the United Kingdom; and the metabolized by-products of cocaine have been found in the River Po in northern Italy. But even more dire conditions stem from the scarcity of clean drinking water. In areas overcome by war, natural disasters or poverty, water-borne diseases contribute to the death of over 2 million people annually. The United Nations has officially designated March 22 as World Water Day in order to bring attention to the severity of global water problems. UNICEF, for its part, has developed a

"Basic Family Water Kit," to be deployed within 72 hours in areas stricken by emergencies. The Kit includes "a collapsible bucket, bars of soap, purification tablets and instructions for their use in the local language." Water-related natural disasters are the primary form of disaster to strike. And water is frequently the source of conflict and war. In Bolivia, "water wars" broke out in 2001 over the privatization of the community's water supply. In this scheme instigated by the World Bank, every drop of water, including rainfall, was subject to a charge. With the increasing scarcity of freshwater, the conflict and cost of water is only projected to rise. In a time when all sorts of errant chemicals are turning up in our drinking water and many people in the world lack even basic access to clean water, SIMPARCH's project brings critical attention to the dirt that is always circulating in our water, from waste to tap and beyond.

The *Dirty Water Initiative* intervention is part of a number of projects at inSite_05 that address contemporary issues around the Tijuana-San Diego border. inSite interventions typically culminate from a two-year artist residency in the area, which allows artists to focus on issues specific to these communities. Tijuana and San Diego constitute an urban region that in many cases is sharply divided by the border between Mexico and the U.S. Access to clean, free or affordable water is just one of the striking issues that characterize the economic disparity between these two cities. Moving between Tijuana and San Diego, and across such a volatile border zone, inSite gives rise to different ways of conceiving of the city, the public, and those infrastructures and resources that enable communities. inSite_05, which spanned three months during the late summer, focused on this region not just through interventions, but also through a number of projects, from museum exhibitions to conversations and archive projects. Over 100 participants contributed to inSite_05, including artists, theoreticians, curators and architects.

SIMPARCH's solar water purification system, located in public space, is ultimately intended to have a permanent contribution to a community in need of drinking water. At once art intervention, public architecture, and independently initiated infrastructure, the project reveals ways in which to expand the resourcefulness of both art and communities. The operation of the water purification system well beyond its life as an art installation resonates with other SIMPARCH projects. From *Free Basin* (2000), a skate bowl fully accessible to skateboarders, to *Clean Livin'* (2004-present), a self-contained living unit in the high desert in Utah, SIMPARCH's projects aim towards a kind of art that moves "off the grid." In the text below, SIMPARCH describes the conceptual basis for its *Dirty Water Initiative*, and its process for manifesting the transformations of water, from pure to dirty and back again.

Agua Gringos

SIMPARCH's project for inSite is about taking the water coursing through Tijuana's pipes and making it fit for drinking. This gesture of purifying water directly challenges the cliché, "don't drink the water". Using the simple concept of solar water distillation, the *Dirty Water Initiative* calls on the Sun Gods for help in heating contaminated water in glass-covered basins. This causes it to condense on the underside of the glass. This condensation flows down to a channel, which directs the distillate through a tube where it collects in a vessel outside of the still. The public exhibit consists of an array of solar stills, a contaminated supply of water, containers for clean water, pipes and fittings. The stills are connected in series, a mini water purification plant. After the exhibit ends, individual stills will be integrated into some of Tijuana's Colonia's. The term colonia is used to represent "informal" communities, colonies, or neighborhoods. Begun as squatter communities, some colonias are 20 or more years old and long since legitimized in the eyes of the government. Levels of development vary greatly. Some have no infrastructure at all, most have electric [often pirated from the grid, however tentatively], some have water piped in, and older, established, communities have water in and even waste-water out to the municipal sewage facility.

> "Water is the blood that nourishes even before the milk can flow"
> —IVAN ILLICH

Land of Opportunity

Most Americans think that TJ is dirty, disorganized and chaotic. After spending time in Tijuana we understood Colonias do fulfill basic needs without the services and infrastructure most Americans expect. The inability of institutions and policy to catch up to, aid, and correct these needs creates a situation where people do more for themselves to make their communities work.

Ivan Illich calls these communities "spontaneous architects of our postmodern future", and the Colonias are demonstrations of "survival on the technophagic fringe". These Colonia-spheres are environments that experiment with more forgiving ways of existence and new forms of conviviality. Not to be revered, the Colonia-spheres should be explored for insights into their resiliency, efficiency, and poetry.

SIMPARCH meets Ecoparque

Through our residency with inSite, we were introduced to Ecoparque. Ecoparque takes the household wastewater and sewage of a neighborhood in central Tijuana and cleans it with simple gravity-fed processes making water safe enough to use on plants. This process generates enough water to make a hillside two acre parcel of land a rich green space. This is achieved through the permaculture techniques of biofiltration and composting with water that would otherwise have gone into the municipal sewage system and ultimately into the ocean. In most of the new informal communities in Tijuana, domestic wastewater is directed away from the house by any means available and often into the unpaved street. This model suggests the potential for water reuse in the communities to stabilize soil and create plant life.

SIMPARCH's dream is that these simple solar-distillation devices become functioning examples of increased hydro-autonomy for the dwellings of this metropolis.

DIRTY WATER INITIATIVE

Abstract
Our very first work together was already our last. Or to put it as Deleuze may have preferred it, we started right in the middle. That work spelled out concerns that would haunt us in whatever work we would subsequently take on together. And the task would be a monumental one. We aptly titled that work *Dencity*, fusing the words density and city, we hoped to call out to ourselves the task at hand: to look, listen to, recover, (re)present, and in some sense stay vigilant to the dense, vertiginous city: the city which is ever changing, ever elusive, reappearing and disappearing in a kind of dance between competing forces. Our approach to studying the city and those disparate forces was, one could say, materialist in orientation. We physically explored, experienced, looked at and listened to the city. As much as we were concerned with the discourses enveloping it, we felt the need to confront those discursive sites with the physical and material developments, locations, and manifestations. The ambition was to have the city stand in for itself, the manifest city, in its everydayness, everyday shifts, slips, hiccups, tremors, stalls, orderings, and movements. For each question, there was a voice, a sound, a time and a part of the city that would offer us insights. All the while, we began to also accrue a vocabulary, for working together, for moving through spaces, for describing what we were seeing, for orienting our conversations with one another and to our public. The terms spanned psychological, economic, and social motivations and effects, including words like amnesia, blithe, corrosion, corruption, desire, exhilaration, flight, fear, neglect, oblivion, emigration, immigration, hope, memory, greed, gentrification, speculation, development &

e-Xplo

NIGHT STARRING COLUMBUS OHIO
SPELLED OUT

redevelopment, renewal, renovation, regeneration, resonance, property, power, silence, nostalgia, speed, tremors, pollution, picnolepsy, private and public 'good', Brooklyn, Manhattan, BQE/LIE, Torino, Eindhoven-Rotterdam, Berlin, London, North Adams, Budapest, Columbus, Newcastle-Gateshead. These are the physical terrains e-Xplo has covered in our short but intensive history together. But as has been our habit, we have always been attuned to the density of information and material that we are co-habiting and co-exploring together. *Sleeping Dogs Lie* is a product of this sensitivity. We began our study of Brooklyn at night, when the restless sounds of the city drifted into quiet ticks, whistles, evacuations, falls, when traffic dissipated, when the night workers and insomniacs took hold to reveal what we referred to as 'the gritty backstage of the city'. Given the fact that we were interested in examining elements of the city that were overlooked or not seen, working at night seemed sensible. What took us nearly 4 years to realize was that the Night itself (not just what took place under its covers) was, par excellence, the unseen and unheard. *Sleeping Dogs Lie* is a series of works that attempts to reorder or refashion our relation and study of the city. Instead of having the night tell us a story about our chosen city, we began to ask the city to tell us a tale about the night. *Nyctalopia* is the first work in this series. We were invited to make that work in Columbus, Ohio by Claudine Isé for an exhibition she curated, *Vanishing Point,* at the Wexner Center. For this "essay", we attempt to construct a kind of atlas or index of terms, which relate to our exploration of Columbus and the under-thought space-time of the Night.

Nyctalopia

Night blindness. We are blind to the night. We awake in the morning to hear our appointed newscasters inform us of what took place the night before. We walk through the city by day. Often we are unaware of what took place there. How the order was created, how the surplus matter, fluids, bodies, refuse, values and even lives were rid of the night before. Which specters arose last night, which desires, which fears or catastrophes? How did we survive the night?

By day, ironically, chance lead us to this word when, on the streets of Columbus, we first encountered night. We had been working largely at night, exploring the city, waiting for Columbus to tell its own night-story, attempting to familiarize ourselves with its geography—the places and non. But what is a city without its people? In antiquity it was believed that you could learn about the city by its inhabitants. We wondered if the same logic would prevail in our study of the night.

Insomnia

MOVEMENT AND LIGHT ARE CONTRASTED TO SILENCE

Backlight.
Working overtime.
Rushes of blank film. Empty, ruined demolished sets.
Endlessly longshots of deserted sets.
Sets that never existed on the shambles' lot.
Bubbles burst. Nothing but breast milk of butterflies.

So we were now seeking some characters, bodies occupying the nightly landscape, voices, people from Columbus who might give us an oral history of nights today or long gone. David R. Lenz seemed like a perfect candidate. He was a passerby, standing at midday on one of the many corners of High Street, waiting for a traffic light when we approached him with our question. He replied that he could be the single worst candidate to tell us anything about the night in Columbus. Among a number of other conditions, he suffered from Nyctalopia.

Ghosts

THE EVIDENCE OF A THREAD THAT WILL NEVER BE FULLY REALIZED

Clearly there are different nights. Nights that are managed, moderated, pinned down, hemmed in, cornered nights. The ones that corporations and city planning boards dream up: orchestras in public parks, gallery hopping on the first Saturday night of the month. But there is a night that is superfluous, that wanders away, and maybe even scares itself. The paranormal night, the ghostly night.

It was our last stop on the last night of the shoot. We drove to R.R.K.'s grave shortly before dawn to film his grave. We had been listening to his music throughout our time in Columbus. *The Inflated Tear* is one of those albums that can cure the loneliest of nights. Moreover, it seemed one of the most fitting soundtracks for this all American city. At times, our entire project veered into a strange homage to one of Columbus's most talented musicians. The more we entertained the idea that his ghost was with us, the more the process of the work headed into the obscure corners of our own imagination.

Not surprisingly, when the film arrived back from the lab, something unexpected appeared onto the original footage. A ghostly purplish haze which ran longer than your standard distortion at the conclusion of a reel. What caused these flashes of light? A malfunction in the camera? Chemistry? Is it a fleeting glimpse of another life form or our own imagination in its delirium?

So often, as artists, we are asked to be correct in every way in the works we produce. Rational accounts. Sensible reasoning. Clear. Transparent. Even useful and functional. Daylight savings time. X for Y. Z for A.

So one can imagine that even for those close to our work, the decision to devote a series of works to the topic of the night would be akin to a turn toward mysticism or the occult. In fact, our most skeptical public has always had problems with our tendency to work with and in the night. To organize our tours of cities at night. As if the night was somehow a flight from what mattered. As if the night could only be a gateway to entertainment or escapism. Unproductive night. Useless night. Obscure night. Fanciful night.

If the night allows the imagination to take hold, ghosts become a pretext to interact and mingle with those presumed no longer present, no longer visible to the functioning world.

Out on Saturday night and I wish I would have someone to talk to.
How I wish I would have someone to talk to.
Oh, another Saturday Night and I wish.......
Let's spend a night together... now.
One night.
Devil's night. I can't take back what is mine. Step backwards, because I can't rule this time.

Home
SOLICITATION OF SENSES AND EMOTIONS

David Lenz lives in a high rise apartment building, alone, in the few rooms that he shares with his three parakeets. There are spells when he stays awake for days. Those nights, with the television on, and the birds flying about the rooms, he'll build WWII model airplanes in the kitchen and livingroom. Amidst piles of paper, stacks of boxes, and books strewn all over the floor, stands a chair, a lamp, a digital clock, a sofa. The furniture retains very little of its original function and has become a "place" within the room where David keeps things. He moves between and returns to them as though they were rooms within the room and wherein each of them a distinctive scene is played out. Though he suffers from Nyctalopia, night has become a very close companion. With night, he sings to his birds, imagines flight through the wings of his model planes, and watches the world through the screen of his television set. When the sun comes up, he'll draw the blinds across the windows. There or then, he may sleep.

Trackingshot
RELATIONSHIPS HAVE MEANINGS

A condensed version of this film would feature two tracking shots. One would mark a night time sequence of surfaces and empty unoccupied spaces. Beginning with a lot of used cars, hovering by thrift shops, clothing stores, shoes, cigars, alcohol, groceries. The other would mark a woman, walking alone, along a nighttime set of empty lots, boarded up store fronts, small churches offering up messages of salvation and hope. She would sing a song about CO (i.e., Columbus), she would sing about a history of oppression, including slavery, she would sing about homogeneity and the attempts to carve out lines of flight.

Streets
THE TRACE OF AN ENIGMA THAT FASCINATES AND FOR WHICH THE CITY OFFERS EXEMPLARY SETTINGS: A FULLY REALIZED LONELINESS AND A REALLY ACCOMPLISHED SOCIETY.

Searching for some pictures to build upon-if only in relation to the diversity and richness of subject matter the temptation to succumb to allegory is strong, in reading these reflections and refractions as a metaphor for the relationship between night and day, right and wrong, good and evil, false and true.

The night cast across a river furthers along the exterior. A bell hangs silent above a closed church. Impenetrable silence. People are urged out rummaging into the stillness, and the depths increase of black above. A paper bag on a cone of water…and, already, words… When the night becomes a mischievous wandering then trumpets blare in alleyways. Rooftops too high for snowdrifts,

Traveler
TRANSFIGURATION OF STATE OF MIND

scream for pulling down, while city lights mask the stars in shadow. Too late for sleep, we are left to our own misgivings amongst the streetwalkers, the sex workers, the taxi drivers, the hangers on. This town was empty before night abandoned it.

The sounds of thoughts, fluctuating and envisioning, sounds of loneliness, sounds of desire, sounds of need, cries for freedom.

The sounds of young men turning old here before their time, Music comes spilling out into the street. Colors go flashing in time.

Appearances

In the night the rausch stands out with prismatic edges against everyday experience. It forms a kind of figure and is more memorable than usual. I should say, it contracts and in so doing fashions the form of a flower.

— WALTER BENJAMIN

Supermarkets. Malls. Parking lots. Fast food. Empty streets. Sleeping Dogs Lie really begins by asking questions about another economy. A social economy that could divert the linearity of these places, exploding their polarization on only one pleasure, on only one disclosure, on only one emphatic discourse.

Rahsaan R.K.

.....Clickety clack

Bubble music being seen and heard on Saturday night
Blinding the eyes of ones that's supposed to see.
Bubble music, being played and showed, throughout America.
Clickety clack...clickety clack
Somebody's mind has got off the goddamn track.
......What is this madness that Nixon has put upon us?
Clickety clack... clickety clack
Won't somebody bring the Spirit back?
Who will it be?
Who will it be?
It certainly won't be someone that says that they're free.
Clickety clack... clickety clack
Won't somebody bring the Spirit back?
Clickety clack... clickety clack ...

Clickety Clack (Bright Moments)

Repetition

THE NOVELTY EXPERIENCE OF FILM

In writing about the Marquis de Sade, Roland Barthes speaks of Justine's travels through cities. Although the destination is in flux as she visits different cities. Their activities are completely oblivious to the changed location. The process remains the same despite the new venue. It is a ritualized behavior that finds meaning through repetition, but not a meaning tied to any identity. Are we seeking to create like Sade's characters some strange utopia in our repetition? Or possibly tracing out the contours to a process we discovered in the blindness of nighttime? With each repetition discovering something new, different.

It is terribly difficult to repeat oneself. The work of Straub-Huillet comes to mind briefly. There is something new which emerges each time one struggles through a particular process or course of action. What remains contestable is how much the repetition of a process or mode of inquiry is about finding differences or looking for the similarities between the different sites of inquiry.

Invisible?

Bodies behind closed doors and within dimly lit rooms. From the street, we wait. Like audience members to a Balinese shadow play, we watch for the traces of figures to move across the surface of the interior walls. Taken together, the gesture of an arm, the tilt of a head, the slope of a back, suggests the sketch of a thought for a lengthier phrase. It's night. I get up from my chair. I cross the room to the table in front of me. Leaning over it, my back begins to ache. Placing my hand on my hip, I retrace my steps, more or less, back to the place I started from. Back at the chair, I sit.

When we think of events, they are often lit, in the light, under the lights, or in the spotlight. And what to make of the events in darkness, do they still exist? What is an event if it cannot be seen? And what to make of all the invisible elements unrealized in the event itself? The world moves within this fog, no?

Virilio reminds us that we are held captive to the speed of light: the transportation of live images, across television screens, finally provide what "Schlegel perceived as the limit of painting when he said that painting cannot deceive us, for it does not have at

its disposal the real hue of the light." And here, at this very moment, in the invisibility that is light, deceitful, deceptive light, the shadow that hides while revealing, we would also have to speak of another world of the senses. In this faltering visibility of night, our eyes are put, finally, on even cue with the rest of our senses. We feel the night with our nose, our skin, our back, our feet, fingertips, organs. The smallest of gestures can tear open an entire space for violence or equally of love, lust.

Why despite all the clichés attached, do we allow ourselves to feel lonely at night, to trust our intuitions, to plot the un-plot-able, to dream, to doze and thus to experience briefly the threshold Benjamin spoke so fondly of?

Small drops, little pangs, the wind, rustling leaves, the rain. We stumble in the night, seeking light and listening, distrustful because we have never listened so intently before. We never heard such silence, such emptiness, such stillness as we do in the night.

Not invisible, but less visible night, more sensual, more sonorous. A night so engaged that it displaces the real hue of light with the many shades of silence, the gradations of a scream, a moan, a whisper, cries for help (or joy). A noisy tonality only Artaud could convey. A monster that could shatter the world as we know it, that could startle and bring fear to even the most unremitting sovereign authority.

No Script

When we enter a city, we often come empty handed. We have some questions, some tools, some predilections, our way of working together, possibly some old records. Enough to fit inside a small suitcase.

Yet at the same time, not having a script means that our process has to be quite robust. We begin by physically exploring the city. Driving and walking through it. Taking photographs, often at night, which involves time, long exposures forcing us to look further. We also collect field recordings, we listen to the city, often seeking the quietest places, the quietest voices. We often begin from the periphery, slowly making our way toward the center. Most often, our stage directions involve some flips and cartwheels. What seems peripheral takes center stage and vice-versa. Questions emerge all the while and these questions are posed to strangers, conducting informal interviews. We seek out voices, our informal historians or narrators.

If we speak with experts, it is most often to give us purview of the dominant discourses. If there are clichés, we would rather have them play out knowingly, but more often than not, we are not interested in replaying

the dominant narratives of the city. When Claudine spoke about inviting us to make a new work, she spoke of multiple sites. One was of course the city of Columbus. But another site was the site of the exhibition, the discursive site of in-between spaces, or Augé's non-places. We proposed the night as one of those in-between spaces, but we did not lose interest in interrogating this notion of non-place.

Driving through the city, it did not take long for us to realize that unlike many of the other works that would be in this exhibition, we would have to concern ourselves with bodies. Bodies that come into contact with the night, and in turn with these presumed non-places. Politically, we felt it necessary to concern ourselves with the overlapping narratives. On the one hand, there was the invisibility of the suburbs, the strip malls, the outstretched parking lots, the endless procession of places with little or no character or history. On the other hand, there were also entire patches of the city, sometimes the most historic, which were equally invisible. For example, East Columbus is an area that many of the characters in our film come from or reside. There we have an area that has so far escaped the neo-liberal enterprise. Has escaped the most recent round of demolitions, the influx of investors, of capital, of malls, of hotels. Each late night market is full of character, dinginess, adversity and perversity, desperation, fear, consolation and familiarity. Empty lots which could easily play host to some future developers' fantasies.

These two types of in-between spaces interrogate one another. Call out the racial and economic undertones that may go unspoken in readings of such spaces. One wondered what laid underneath the shopping mall, what places, what memories had been scattered under the weight of a wrecking ball? One wondered how much luck, will, or resistance was involved in keeping these small spaces of overlapping blithe and hope (depending on one's orientation) alive?

For this film as with many of our previous works together, the script was written through our movements in the city and through who and what we listened to or looked at/for.

In this way the script and the scenes or sequences which unfolded in the film acted as placeholders or markers for stories which presented themselves to us in our time in Columbus.

Journal entry: "In the car, radio up, windshield wipers on, headlights filtered by rain, another night of driving. Who else goes out on a night like this one? Stopped at a red light, the city stage behind us, we turn onto the highway. Only there will we find the roar of motion we need to move this script along."

Generalization

MULTIPLE, FRAGMENTED, DYNAMIC RATIONAL / IRRATIONAL

A night in Columbus can be a night in Canton can be a night in Cleveland can be a night in Cincinnati, small town, big town, shit town, conservative town, Ohio or Oregon, there is surely a generalized night, a night that gives the space of the city back to its people, to imagine or use in a manner unrecognized, unsanctioned, unbelievable to those in power. And for this reason, policed, as in night hours, wee hours, police hours.

Characters

DIALECTIC OF PERSONALITY

For each of the characters who inhabited our film (there were five in total). We wrote brief descriptions.

David Nyctalopic. Blind to the darkness and yet with knowledge, with his vision high on a hill, central command, able to articulate things in ways no one else can, in many tones, octaves, resonances. He knows both the omnipotence and futility of vision. Thus he sits at the eye of the storm, beckoning us all to the end of the night, to that bright midnight.

For the work, David also stood in for those endless bodies who crumble before their television sets across the country on every night, in every town. All knowing, all seemingly seeing, but basically asleep or blind to what goes on outside their windows each evening. Consequently, we shot our footage of David in his apartment, inside a social housing project, one of the few high rises in the eastside of the city, adjacent to the expressway. The building is located in a part of town that was probably one of the centers of night life in the city.

Chyna She is the dream that arrives only by night. And dreaming by night she com-

presses, condenses, extrapolates personal desires and open wishes with the realities of history and exploitation. Chyna is a vision of a distant land, a far off future that belongs, is born only in the night. And for this, striving to be lit in the darkness, she risks and fears never being discovered, never being seen nor heard. For this flicker, this clamor, she risks burning out, risks losing footing from the weight of so many hopes, so many untold stories, so many dreams.

In a donut shop Chyna told us she'd been in Las Vegas the past year singing in clubs. At twenty one, and having never left her hometown, she had packed her bags, bought a bus ticket, said good bye to her mom, and left. A music producer invited her to come out to put together a record. He said she had talent. They met online. When she arrived he offered to share his apartment for the first few months, while she made her way around. She spent nights walking through the crowds of downtown Las Vegas and calling her mom from the pay phones. The producer booked her a few shows to sing lounge music at some big clubs but relations became tense when he wanted her to sleep with him. She moved out. She had never lived on the streets before. She had family back in Columbus that she could return to but she wanted to make a name for herself and then fly back. Plus, she didn't have enough money to buy a bus ticket since the producer hadn't paid her for having let her stay for free. She moved into a shelter for women and children. She started singing at the shelter and became well known for her ability to improvise and for the sound of her voice. The women gave her a nickname, Ray, for the hope they received from her songs.

Willie Willie is toil and labor. He has been there and done that, seen a lot, been through more. The old wise man. He sees the turns coming days before they arrive. Looking beyond the darkness to the light. He is the coin that always falls in your favor. He is the long day's journey into the night.

The history of the nights in Columbus lives in Willie. But the song he sings in the film speaks of another night. It was his own song, one of the few in which he penned both lyrics and the music. He is the thread connecting the gospel to blues to jazz. He is the thread connecting the nights in Columbus of the 50's to today. On one occasion, we asked him to take us through some of his night stops. The highlight of the evening was the Elk's Lodge. A sleepy bar with characters that seemed to have walked off the set of a film and decided to stay on.

D'Angelo The youthful engine that keeps the night roaring along, either by being the rhythm section or by his simple driftings. His late night walks. He needs to lose himself for the whole thing to stay afloat.

We stumbled upon D'Angelo Kirk as we had pulled on the side of the road to look at a map. He was walking alone, listening to his headphones, drumming along. The recognition was instant. On each night, we had seen someone like him, walking along the road, alone, hood over the head. We exited the car, caught up with him at the gas station and asked him to be one of the characters in our film.

Rahsaan Roland Kirk The ghost of the night. Our ghosts come to us by night. Both forgotten and remembered. He is the shadow of another path. Rahssan is also the history of dreaming and in this way, he gives light, through his blindness, his incapacity to see. He gives light to us all. A path through his ear into an infinite and entirely unexpected night.

It was in a dream that Roland Kirk was delivered the name Rahsaan. And it was also in a dream, asleep at night, that he had a vision of himself playing multiple instruments at the same time. This would be the discovery that would land him on the map. He was eclectic, misunderstood, an incredibly gifted musician. Blind. In his native Columbus, never fully given his due, never fully recognized. In this sense, he was a fitting thread, one of the narrators that Columbus offered to us, in our story about the night.

Original Sound

DIALECTIC OF REMEMBERING AND FORGETTING. City. Memory. Fragmentation and Oblivion.

Our soundtracks often involve a juxtaposition of not only different regimes of apprehending and organizing our shared acoustic environment, but also different sources/modes of production and acquisition.

We have always attempted to emphasize sound in our work and this film is no exception. Orson Welles, who was quite used to working exclusively with sound in his radio work, once remarked that he made his films so that those who could not see could still understand and experience his work. Godard is another filmmaker that has remained meticulous about his use of sound. Yet both of these filmmakers, like many of the best, have fallen for the trap that Alain Badiou speaks of in his short but emphatic essay "Philosophy and Cinema."

The central problem seems to be the following: could a rhythm be invented which would tie cinema to the real of music as art, and not to the decomposed forms of symphonism or the demagogic forms of youth music? How is it possible that cinema has left aside the entirety of contemporary mu-

sical creation? Why, besides post-romanticism and post-jazz, isn't there a cinema of post-serial music?

For this film, we worked with a whole range of sound and musical influences. From the post-serial music that Badiou speaks of to Gospel and Jazz. We recorded in bars and clubs in the city. We recorded out in the streets, long silences, sirens, whispers, clicks, rustles, the howl of locomotives. And of course, we worked off of the original scores of other films, other representations or evocations of nighttime.

This film, along with our other soundtracks, has been an attempt to reference, play with, and respond to earlier constructions of acoustic landscapes in the cinema. We have always seen our sound work as the construction of soundtracks for given sites. But rather than imagine that the sound would capture or reconstruct what unfolds visually for a viewer, our sound questions, interrogates and informs what one is looking at.

Willy sings his song. It is the moment around an absence. Absence, break, hole, fold and rupture, and…
The music drops, removing a signal and leaving only its effects to be heard, imagined…
A glitch or a sudden absence of sound opens a fissure for questions about distance and loss, time and memory, encounter and unfamiliarity.
The sounds of thoughts, fluctuating and envisioning.
Sounds of loneliness, sounds of desire, sounds of need, cries for freedom. The sounds of young folks turning old here before their time.

Music comes spilling out into the street. Colors go flashing in time. Night clubbing—as I lick your lips…they turn to stone. Open the hedge and die. Moving slowly through the high-rise. Lock the door.
Left with nothing.
Night clubbing. We learn about dances, brand new dances!

Hold on a second, is someone speaking about love here?

Ordinary homes or empty lots here become the sites of legendary performances. Time is linear only for those who believe in progress. Most of this history has fallen through the cracks, leaving little trace, aside from a few photos, small personal archives, and the obligatory empty lots, boarded up buildings. Here, the time to remember is also a place to forget.

Livingston Avenue

A DIALECTIC OF PLACE AND PLACELESSNESS

One could write a history of this city at night by tracing through Livingston and its surrounding area. Livingston Avenue was one of the main arteries through which much of the history of music in Columbus, particularly great jazz music, ran. There were clubs, some marked and glamorous in their day and others hidden, nested in basements and seemingly more residential parts of the area. An entire life of a people ran through these streets. Behind some of the first tier Jazz towns like New York, Chicago, Detroit, Boston or New Orleans, there were second tier towns, nearby cities like Columbus, which earned themselves a reputation for great music. They were not the stops that would make a name for a musician, but the ones that would earn them their stripes, possibly pay for a few drinks, and with some luck some warm food, a place to sleep.

Columbus historically brought together a nice mix of local musicians and legendary performers who would rumble through town on their way to the shows in bigger cities. Many of the greats made their way here. And driving with Willie around this area served a virtual tour of this history.

A few scattered clubs remain like the Cannabar or the Macon Lounge. We found ourselves at these clubs on some evenings. Long past their heyday, but still holding some memory of those endless nights. Nights in which closing hours no longer mattered, because the music held bodies together, in a temporary shelter or refuge from the cold, from the differences which are most often emphasized and most often call on individuals to remain in captivity, in isolation. Nights in which twenty minutes could unfold into 3 hours and 3 hours could feel like a life lived to its last drop of sweat.

Uncanny
DIALECTIC OF DEATH

Canny and uncanny. Home and Road. Shelter and Shock.
Take two steps!

Music?
DIALECTIC OF ENCOUNTER

In his book, *Noise*, Attali divides our sonorous apprehension of the world into three categories: noise, sound, and music. Each step suggesting a slightly more controlled, formalized, and regulated experience of our acoustic environment. Within this logic music is heard as the most economically and politically mobilized. In this work, music is an encounter with the unfamiliar. Its formality questioned. Its play-ability, its malleability recognized and exploited.

Despite our wish to provide a surface for the representation of an original event, a stable protector of the preceding mode of organization, the soundtrack acts as a destabilizer.

Don't feel so bright. Don't care. Black night, it is on a highway I don't know. Intoxicating… a long way from home.

And yet, even if many of the actual places have disappeared, the force of these intensive flows, of bodies, movements, gestures, and of tacit knowledge, of know-how have left their mark on the city. The two notable music programs in Columbus are arguably a by-product of those long nights, of that history that unfolded on and around Livingston.

If memory is sewn together to time, forgetting is woven and unwoven in relation to place. Anthropologist Richard Etlin once made the point that space becomes place as we become. One wonders what becomes of forgetting.

Bar. Cannabar. Unload our gear

THE LEGEND.

Cannabar is a live jazz club, which means that people live in the jazz. Pulse of this city. Driving, we zigzag through Columbus while Willie confirms reflectively that there were, are still, arteries, intersections, blocks, where musicians gave birth to jazz and jazz gave rise to musicians. Proud musicians whose beats conjure up the rhythms of a dying past in a lived present. Pulse of their bodies. At the Cannabar the CROWD appreciates music, as in the Latin *appretiare*: to praise, or be keenly sensitive to shades of meaning. A crowd, CROWD, comes together if not for words, or drink, or story, for tales told through instruments of voice, of trumpet, drums, saxophone. End of the night.

Why are metaphors of cohesiveness usually applied to the past and fragmentation to the present? Why are some bound to the endless night?

Stranger.

What is a stranger? Who is a stranger? How can we talk about the stranger? Where do we meet her/him? What distinguishes the stranger from somebody else? How long can someone be a stranger in one place? Traveler. Tourist. Refugee. Enemy. Friend. Guest. Outsider.

Encounter. Introduction. The recording-devices longing for the moment that is real! The intersection of emotions, objects, places, a look of things and a way of acting, partly real, partly staged. Perhaps we have agreed upon our strangeness. And put the recording devices between us. Because it is strangeness that connects us.
Strangers in the night…nananana…

Ohio

It was interesting to discover that Columbus, Ohio is demographically speaking the center, the median, the average America. For this reason, it is the site of countless fast food chains, franchises, and other retail or corporate studies/experiments. The state was also one of the more closely contested in the 2004 presidential election. It is this mediocrity, its slumber in the night, and the restless bodies which resist or rub against it that this work struggles to outline. Even if what one is confronted with is the repeated, the homogenous, the characterless, the generalized, the history-less, the non-places of the night, of the mall, of the familiar assemblage or road-fast-foodchain-parkinglot-gasstation-shoppingcenter: we have to also assume as de Certeau argues in his *Practice of Everyday Life* that the powerless discover various tactics of resisting, of creating.

Hope	**Insecurity**
An urge. A wish. A lost hope. A fulfillment.	*SPEECHLESS* Rene returns from a drive near David's with a shot of a building with no face. It is ripped, exploded, torn. It is a nightmare. Yours. Mine. Ours. We'll begin the film with this shot. To enter the film with a scene one could never return to introduces holes of memory, of lives, of fabric. Two tons of trapped concrete. Just to know how hard it is to leave this place, and to even think of it may lead to future disasters. Where is home when one can never return? When one knows, not just recognizes, but is aware that she can never go back? Never back to the relatives, the aunts, uncles, grandmother, half sister, who no longer exist in this town or of this world.

Obscure

The world is deep: deeper than the day can comprehend.
—FRIEDRICH NIETZSCHE

Obscure night. Imperfect night. Muted, but not withholding anything but light. Defiant and resistant to the notion that thought or sight could corner it, could hold or behold it. This is not the night of secrecy, but patient, honest night.

Like a street, a voice gives passage to their lives. In the act of passing from one period to another, of writing, of season, of composition, one makes a journey of small or moderate length. Because Chyna knows that verbal interchanges are never so far from urban ones, she is melancholic as she sings of Livingston Avenue. Miked, we record her quiet meandering voice weave its passage complete with sign, and reference though illusory for without night her images fade. By day, Livingston is a bleak reminder of enterprise, no longer, but once a hair salon business owned by her family where she would thrive in endless afternoon hours. And yet in this film, night affords her the emptiness to dream in it.

Our hours are scribbled out on papers laid out on the two twin beds of the motel room. Phone numbers. Restaurant receipts. Addresses. Clubs. Clues. Their visuals are gainful and equably square. Note one: Two helicopters take off into the night. Note two: Outdoors a car goes uphill in a genial low gear. Note three: A girl is lying on her stomach with one eye closed, driving a toy truck along the road she has cleared with her fingers. Note four: At night, a man alone sits at his table, again, immersed in the habit of thoughtfully confessing that ignorance of tomorrow freely will admit to everything. Question: Shall we return to these places? Answer: Impossible! For street lights embellish where sight before ventured. A distant rain sounds dimmer by candlelight. The

world as we write it is fading away. Listen! It is the night that affords us a city in all of its solitude, and arouses one to see into it.

And in this way, it seems fitting that it would not be our own writing that would seal this process, but a riposte from an old friend, Maurice Blanchot. With a scolding and yet consoling tone, he offers:

Despite your efforts to avoid having to evoke light in speaking of the obscure, I cannot help but refer to everything you say back to day as the sole measure. Is it because our language has become abusively – necessarily – an optical system that speech speaks well only to our sight? I wonder whether Heraclitus, when he says of sacred speech that it neither exposes nor conceals, but gives a sign, is not saying something about this. Might one not lend him the idea you wish to present: that there is a language in which things neither show nor hide?

P.S.

"There is no P like Poetry in Night Starring Columbus Ohio"

Scott Berzofsky
Nicholas Petr
Nicholas Wisniewski

NOTES FOR AN
OPPOSITIONAL URBANISM

NOTES FOR AN OPPOSITIONAL URBANISM

INTRODUCTION BY MICHAEL RAKOWITZ

For four years, I had a very specific relationship with the city of Baltimore. As a full-time instructor at the Maryland Institute College of Art (MICA) from 2002-2006, I found myself spending close to half of each year in Baltimore, while maintaining my permanent residence in Brooklyn. Weeks were divided into two: one beginning early Monday mornings on an Amtrak train heading south, the other late Wednesday nights on a train heading back north. It was on the train heading south that I paid close attention to the way in which major cities like Philadelphia are presented in a dramatic, almost heroic choreography. As trains running on Amtrak's Northeast Regional line start to slow and rumble towards 30th Street Station, the passenger is presented with the promise of another American city, the skyline reaching and sprawling. Then the train pulls away, continuing southward, and we can see the backstage, the gritty factories and industries. Then come the bombed-out, boarded-up row houses. Avenues of them. One hour later, past Wilmington, Delaware, the train starts to slow and rumble once again. In the distance, one can make out several high-rise buildings near the touristic Inner harbor, some post-modern structures that house offices and convention centers. No theatrics. The backstage comes first. The avenues upon avenues of boarded-up houses are back, this time amidst demolition piles. Newly empty spaces are being transformed into parking lots. Gaps in between buildings present a vivisection of life in these disappeared structures: a descending trail of bricks on the side of one building suggests a stairway here, a pink bit of wallpaper and half a mirror a bathroom there. Johns Hopkins Medical Center looms in the background. East Baltimore, gateway to Baltimore City.

Scott Berzofsky, Nick Petr, and Nick Wisniewski are members of campbaltimore, a collective consisting of artists—some of whom graduated from MICA—activists, and organizers who arrange workshops around critical cultural, political, and social issues in Baltimore. Much of their work has focused on the problematic nature of "urban development" in their city, and their participation in exhibitions such as "Under Construction" (curated by another MICA alum, Michael Benevento) at Current Art Space in September 2005, as well as the "Crowd of the Person" exhibition at the Contemporary Museum, has yielded meaningful projects that provide platforms through which citizens who are disenfranchised or marginalized are present and not simply represented. campbaltimore forges relationships with collaborators based on solidarity, communicating their strong commitment to radical civic action and utilizing cultural institutions and community spaces to engage citizens.

On April 17, 2005, I had the opportunity to experience a bus tour organized by campbaltimore as part of the planning for "Headquarters," an exhibition at the Contemporary Museum. Inspired by "The People's History Bus Tour of Baltimore," campbaltimore, in conjunction with museum curators, organized the participation of many of the activists, educators, and citizens that had produced the original tours in the 1980s. Updated to focus on current issues of urban crisis, the project presented the problematic topography of the city, one that the visitor who is shuttled in between ball games at Camden Yards and crab feasts at seafood restaurants rarely sees. As the bus rolled and slowed before each space that told some story of urban and human ruination, I couldn't help but imagine the tour as an intervention in a Fodor's guide to the city, unexpectedly leading the traveler into zones that communicate a history of crisis—a truth emerging as the façade of the city recedes.

Tourism, Official History, Counter-Memory

To compose a tour of a city is to engage in an editorial process of inclusion and omission that is never politically neutral. A tour, like any other form of visual or linguistic representation, is a discursive construction that does not provide an unmediated experience of a city, but rather works to frame the city within a historical-geographical narrative that is inevitably informed by the ideological position and economic interests of its authors.

These conditions are rarely acknowledged in the official histories of cities like Baltimore, which invest tremendous amounts of money in the production and administration of positive self-representations. Visitors to Baltimore are invited to experience the city as a series of sites for leisure, entertainment and consumerism all safely contained within the central downtown area. While this sort of tourist activity may seem like harmless family fun, its implications become increasingly corrupt when we consider all that is excluded from the celebratory narrative of "urban revitalization" and "progress." Poverty, homelessness, segregation, vacant buildings, police repression, a public education system in crisis—to name only a few of the less attractive features of the city—are found nowhere within the limited scope of Baltimore's official tours or in the vast amounts of literature available at the Visitors' Center. This suggests that the tourism industry is part of a larger enterprise—a marketing and public relations machine that works to construct a positive, profitable image of the city while concealing social inequalities.

As an alternative to the affirmative, cliché history promoted by Baltimore's tourism industry, exists the oppositional tradition of People's History Tours oriented towards the production of counter-memories of the city's labor, civil rights and women's struggles. Initiated in the early 1980s by a group of local historians and activists, the first People's History Tours traveled by bus through the city and stopped at a dozen sites where local historians would meet the group, give a presentation and answer questions. The tours became so popular that the organizers could not satisfy the demand for them, so they published The Baltimore Book—a tour-guide of sorts—that would provide information for people to take the tour on their own.[1]

1. *The Baltimore Book: New Views of Local History,* edited by Elizabeth Fee, Linda Shopes, and Linda Zeidman, Temple University Press: Philadelphia, 1991.

More recently, as a collective, we have organized several tours in collaboration with many of the same historians and activists who worked on the original People's History Tours as well as others. We have found that as a form of knowledge production the tour—which is fundamentally social—is open to a multiplicity of voices and perspectives. This capacity for internal debate allows the tours to remain provisional and resistant to the authoritarian dogma of a single narrative and the reification of official histories. But we recognize the potential danger of the tour: to facilitate a passive mode of spectatorship that is ultimately complicit with the conditions of the city rather than critical of them. Such passive complicity can only be avoided if the tour functions not as an end-in-itself, but as a point of departure for further discourse and action.

This article extends our engagement with the legacy of the People's History Tours and The Baltimore Book by attempting to map a critical geography of the city and present models of resistant activity that are excluded from the dominant narratives. The form reflects the different voices of the article's multiple authors. It can be read as fragments from a tour of Baltimore, notes for an oppositional urbanism.

114
NOTES FOR AN OPPOSITIONAL URBANISM

Urban Redevelopment

Signs of what is often referred to as "urban revitalization" or an "urban renaissance" can be found all over the city, where construction sites, large cranes, and the logos of major developers are a common sight. The self-proclaimed renaissance has been the focus of city policies since the mid 1960's, when the construction of One Charles Center signaled the beginning of an effort to attract investors and a work force of urban professionals back to the downtown area, which had been nearly evacuated after a decade of migration to the suburbs. Development has continued to move in this direction, with emphasis on retail spaces, offices, condominiums, hotels, a convention center and sports stadiums (all subsidized by public funding and tax exemptions). What has emerged is a city center of luxury and consumerism serving those who can afford to live and work there but failing to meet the needs of ordinary citizens.

Driving much of this redevelopment are several quasi-public agencies dedicated to marketing Baltimore to visitors, investors, businesses and residents. Some of the most prominent are The Baltimore Area Convention and Visitors Association, which works to attract tourists and conventioneers to the city; the Downtown Partnership of Baltimore, which advocates for the interests of the downtown business community and works to maintain a clean and safe environment for business; the Baltimore Development Corporation, which acts as a mediator between private developers and the city government; and the Office of Promotion and the Arts, which supports cultural initiatives that help to make Baltimore an exciting and beautiful place. All of these agencies are engaged in a common economic, political, ideological and aesthetic project to position Baltimore as a competitive destination.

Mt Clare Shopping Plaza

After the assassination of Martin Luther King, Jr., in April of 1968, rioters destroyed several traditional low-income shopping areas, including stretches of West Baltimore Street. Some years later a partial ring-road was constructed to allow traffic coming up from Washington and further south to skirt the congested streets of the central business district. Named for Dr. King, the boulevard's six lanes of heavy traffic ironically serves, whether intentionally or not, as a discouraging moat between chiefly African-American West Baltimore and the downtown. One certainly unintended consequence of its location was to discourage development vectored in the other direction, most specifically the expansion westward of the University of Maryland facilities across the boulevard into what was beginning, in the 1980s, to be a vibrant artsy area around the old Baltimore and Ohio Railroad roundhouse and the Hollins Market. In anticipation of that expansion and of the arrival of middle-class residents (the lawyers and doctors and nurses working on the University of Maryland campus—restaurants, art galleries, and, eventually, an upscale shopping center, anchored by a large Safeway supermarket, were built. But the boulevard proved too powerful a barrier. Gentrification stalled, the restaurants and shops gradually failed, and the shopping center was obliged to readjust itself to serve a low-income clientele. Only in the last year has the University of Maryland built a new facility west of Martin Luther King Jr. Boulevard, so it is too early to predict its effect on the neighborhood.

BY NEIL HERTZ
THE PEOPLE'S BUS TOUR OF BALTIMORE BOOK, APRIL 17 2005

Interstate 83

As plans to redevelop the downtown/inner-harbor region of the city progressed, city planners realized the need to construct a commuter route that would allow workers and shoppers from Baltimore's northern suburbs to travel into the city while bypassing neighborhoods that were perceived to be dangerous. Such a road would also function as a physical barrier between the newly renovated financial/tourism district and the lower class neighborhoods (now predominantly African American) of Baltimore's East Side. This commuter route took the form of interstate 83 and followed the path of the Jones Falls water-way. At one time this body of water had carried clipper ships north to the mills of Hamden, but had slowly been reduced to little more than a stream. As a natural barrier, the Jones Falls was not effective enough, but coupled with a six-lane highway it worked to enforce Baltimore's boundaries of race and class.

BERZOFSKY | PETR | WISNIEWSKI

Uneven Development, Urban Blight

In contrast to the affluence of downtown and the Charles Street Corridor, which are experiencing a flurry of investment and development activity, the majority of the city continues to decline. The struggle among residents of East and West Baltimore's most neglected neighborhoods to maintain basic resources (grocery stores, medical facilities, schools, social spaces, etc.) is becoming increasingly difficult. The systematic disinvestment of resources from these neighborhoods over the last several decades has produced the conditions of blight which are now used by politicians and private developers to rationalize corporate-friendly urban renewal plans as the only solution. Incidentally, this process of disinvestment has also created profitable investment opportunities for many of those same parties.

The uneven geographical development of Baltimore—between affluence and impoverishment—registers in physical space the extreme social and economic divisions that exist within the city.

The Johns Hopkins Medical Center and Biotech Park
The Johns Hopkins Medical Center towers over the surrounding residential neighborhood of middle-east Baltimore, which has steadily declined over the last several decades despite its proximity to this world-class research institution. Some residents argue that Hopkins itself has contributed to the neighborhood's current condition of decay by land-banking large numbers of properties in the area and allowing them to sit vacant for years. The long held local suspicion that Hopkins would eventually seek to expand its campus into the area was confirmed when the plans for a new biotech park were announced. A partnership between the city government, Hopkins and the non-profit East Baltimore Development Inc. (EBDI), is using eminent domain to acquire 80 acres of land in the area, effectively displacing hundreds of life-long residents and local businesses. In response to this urban renewal plan, residents formed the Save Middle-East Action Committee (SMEAC), which has fought successfully for safer demolition practices and fair relocation packages.

Police Tactics and Surveillance
Since 1996, when the Downtown Partnership introduced the first surveillance cameras to parts of the central business district in an effort to provide a sense of security for office workers and tourists, the network of cameras patrolling public spaces in Baltimore has expanded to cover most of the city. The cameras are intended to deter crime, but many argue that they only displace it to other parts of the city while failing to address the social problems—such as widespread poverty and unemployment—that contribute to it. More recently, the police have deployed a new type of camera in high-crime areas equipped with blue flashing lights and adorned with the Police Department and Believe campaign logos. In other areas, gas-powered flood-lights are turned on all night to illuminate entire streets as part of a panoptic program of discipline and control that criminalizes whole neighborhoods.

The General Motors Plant on Broening Highway

On Friday the 13th of May (appropriately), 2005, General Motors officially closed this plant, commonly known as "the Broening Highway truck plant," displacing about 1,200 workers, and placing another tombstone in the graveyard of American manufacturing industry. The workers from Baltimore joined an increasing number of GM workers—totaling about 40,000 by the beginning of 2006—who have been displaced from their factories.

The Baltimore metropolitan area has lost more than 30,000 manufacturing jobs since 1993, devastating existing communities and dramatically shifting the expectations of working-class children. The work has either been shifted to low-wage countries outside the United States or has been absorbed by technological improvements. Economist Jeremy Rifkin predicts, however, that by 2050 only 5% of the global population will be needed to produce the world's industrial goods so the end of the industrial age in Baltimore is simply a preview of the global economy in the 21st century.

The closing of the plant symbolizes the end of U.S. dominance in the global economy, as General Motors has seen its market share of vehicles decline and its bonds now rated as "junk." Its main supplier, the Delphi Corporation, has threatened to declare bankruptcy and Toyota should pass GM in 2006 to become the world's largest auto producer.

GM accomplished the closing with virtually no organized opposition from the workers. For many years, the UAW-GM National agreement included a special letter, listing the plants that GM would not be allowed to close during the term of the contract. In the UAW/GM negotiations in 2003, the letter was continued but the Broening Highway plant was removed from the list, and the deathwatch began.

Under the existing union contract, workers should have wages and benefits protected until September, 2007, and are eligible for transfer to other GM facilities in the US. The threat of a GM bankruptcy filing, or a reopening of this contract, however, could significantly alter this benefit. No matter what happens in the short term, the long-term disruption of the lives and communities of the auto workers is beyond calculation.

BY BILL BARRY, DIRECTOR OF LABOR STUDIES,
COMMUNITY COLLEGE OF BALTIMORE COUNTY, DUNDALK

Prison Industrial System

Baltimore City African American residents are to this day continually impacted by the legacy of racism and disparity of economic resources embedded throughout education, health care, employment, etc. This has resulted in poverty, drug addiction, and participation in the street drug economy, and has led to a disproportionate number of people of color impacted by the criminal justice system. Specifically those who are arrested, on parole or probation or are currently incarcerated in the Maryland State jails and prison system

In Baltimore, nearly one in five African American men, aged 20-30 are in custody and statewide, it is one in ten. Less anyone be deceived, the incarceration rate is not growing because there is a rise in violent crime. Most people incarcerated in Maryland are for nonviolent offenses, many of them drug offenses. African Americans represent 68% of people arrested for a drug offense and 90% of people incarcerated for a drug offense, though they represent only 28% of the population. More than half (52%) of African American men, 20-30, are under justice control on any given day (jail, prison, parole, probation)

Women are now the fastest rising prison population. Women made up 7% of all inmates in State and Federal prisons last year and accounted for nearly one in four arrests. Between 1986 and 2000 the general incarceration rate of women grew 400%. African American women in Maryland are incarcerated at 4.2 times the rate of White women. Black children (7%) were nearly 9 times as likely to have a parent in prison as white children (0.8%)

The growing incarceration rate is attributable to the impact of poverty and America's so-called war-on-drugs. Furthermore, all ex prisoners in Maryland face the following restrictions when they are released:

- Restrictions in employment—many employers do not hire anyone with a felony arrest or conviction
- Restrictions in obtaining public housing
- Restrictions in public assistance (TANF)
- Restrictions in drivers licenses and ID's
- Custody and other children issues—mostly impacts women
- Voting disenfranchisement

Also, when comparing costs, such things as education, community and job development, and drug addiction treatment cost far less than the cost of incarceration. The average cost of incarcerating one individual is approximately $24,000 per year. However, it costs, on average, around $4000 to $15,000 for drug treatment for one individual for one year. We spend about $8,000 to $10,000 per student per year in Baltimore City Public Schools. The Maryland Department of Corrections budget has grown from $293 million in 1990 to $1 billion today. The Sentencing Commission acknowledges that Maryland's use of alternative sanctions, such as treatment, has reduced the annual cost to house an offender by more than $15,000 per year.

SUBMITTED BY POLLY RIDDIMS
CRITICAL RESISTANCE BALTIMORE AND FUSION PARTNERSHIPS, INC.

Reclaiming Social Space

Against the rapid privatization of public spaces within the city there exist some modest alternatives that suggest the potential for autonomous groups to reclaim spaces for social and agricultural uses. The following two examples (which are by no means comprehensive) demonstrate how ordinary citizens can participate in the production of spaces that serve their own needs and desires rather than those of capital. They stand in stark contrast to the undemocratic process of decision-making which characterizes urban planning in Baltimore, in which the luxury and security of a privileged few come before the basic needs of entire communities.

The Amazing Port St. Project

In the spring of 1998, Pastor Karen Brau began gardening in the backyard of The Amazing Grace Lutheran Church. It was around that time that she discovered city redevelopment plans which included the demolition of the abandoned houses lining the east side of Port St. next to the yard. Pastor Brau realized the risk that certain types of development could pose for the Port St. garden and the potential for the members of the community to organize and benefit from taking over the empty lots. She contacted local community organizer Glenn Ross and they soon discovered that by 2000, the homes on the west side of Port St. would come down as well.

In response to the desire for neighborhood residents to determine how the space would be used, The Amazing Port Street Project was born. Lot clean-ups were organized and gardening continued. Locals, artists, students, and a variety of volunteers, gardened, planted grass, and constructed totem poles that stand in a labyrinth of stones, rubble and flowers. Pastor Brau says that the Port Street Project was designed to cultivate the land (and community) creating a green space for meditation and learning.

The creators of this project reclaimed 21 properties, many of which they did not own. They saw this as an opportunity to take back what had been neglected and make a community friendly, community maintained place for growth. 9 of the 21 properties occupied by The Amazing Port St. Project are still owned by the city of Baltimore. The Project has been in conversation with city officials since 2001 and has taken all the proper steps to legally acquire the properties but the government remains resistant to handing over control to these residents.

PHOTOS BY PASTOR KAREN BRAU

Wino Park

St. Vincent De Paul Catholic Church stands a few blocks from Baltimore's Inner Harbor, at the southern most point of interstate 83. Adjacent to the church, is a small park, commonly referred to as Wino Park. The name is the result of a homeless population who have, over the years, claimed and reclaimed this space as a place of social activity and rest. As Baltimore's Downtown tourism and convention boom crept closer to Wino Park, the city property was put up for sale, most likely in the hopes that some developer would purchase the land and build. At the time there was also increased pressure from the city in the form of police tactics, to rid the downtown area of vagrants. The enforcement of anti-encampment policies were making it more difficult than ever before for homeless residents to find a safe place to rest.

Father Lawrence, a resident at St. Vincents since 1973, responded by negotiating the sale of Wino Park to St. Vincent de Paul Catholic Church, a decision that was made according to Fr. Lawrence, out of fear of "waking up one day to an 11 story building."

Once purchased, a decision had to be made about how to use the park, and the church saw no reason to change its function, and the decision seemed to be in the best interests of the Wino Park's residents, it was certainly not in those of the Baltimore City government.

The Mayor's office continues to pressure the church to clear the property of all persons residing there, and some accuse Father Lawrence of enabling vagrancy and drug use rather than aiding these individuals in there struggle. He says that he sees a safe place of rest as an important step toward treatment or recovery, and that the city has provided no comparable alternative property, for this type of use. The park is private property, safely located across the street from police headquarters, close to local shelters and food kitchens, not to mention its close proximity to the Inner Harbor—ideal for panhandling.

MAKING NEW YORK BETTER EVERYD

Jennifer Gabrys

PAPER MOUNTAINS, DISPOSABLE CITIES

REFUSE REPORT: NEW YORK CITY

1. The Paper Deluge

We are drowning in paper. From cramped urban apartments to monumental landfills, sheets, stacks and reams saturate and consume space. Suddenly swamped by a steady, decade-long tide of printed matter, a Bronx man was trapped for two days in his ten-foot by ten-foot room in December 2003. Wedged in but standing upright, Patrice Moore was buried when his collection of books, newspapers, magazines and junk mail collapsed. Fifty garbage bags of paper and one hour later, emergency personnel finally "unpapered" Mr. Moore down to the waist. From floor to ceiling and wall to wall were copies of *Vibe* and *Scuba Diving*, ad sheets and books that, according to *The New York Times*, "he ordered with a variety of names and never paid for."[1] Mr. Moore intended to sell the books and papers on the city's streets, but instead found himself entombed by communications in a windowless room. Another urban landscape, vastly magnified in scale, is similarly flooded with heaps of paper. At the edge of New York City on Staten Island four mounds of refuse spanning over 2,200 acres form a shifting terrain that also threatens to collapse. This monumental site, the Fresh Kills Landfill, is composed principally of paper. All manner of discarded print, from newspapers to magazines, posters and flyers, congeals in sprawling mountains which, together with assorted food scraps and household remains, tower up to a sizeable 225 feet. Newspapers dating from the late 1960s have been preserved in the tight and dark spaces of rot. A site that documents recent cultural histories of consumption, the landfill looms to such an impressive size because nearly 50 percent of its contents consist of paper.

The landfill is a site of invisible, even disappearing geographies. It marks the disappearance of the city.[2] Disposal of paper performs

1. "Bronx Man Is Rescued From His Own Paper Prison," by Robert D. McFadden with Oren Yaniv and Michelle O'Donnell, *The New York Times* (December 30, 2003: Section B, Page 1, Column 2).

2. This disappearance of the city was enacted in an even more visible way with the removal of debris from the World Trade Center towers for temporary and permanent storage at the Fresh Kills Landfill in 2001.

a quick and constant extraction and outward flow of urban matter. The extraction process that occurs in the flow of printed matter from city to peripheral landfill is analogous to the extraction process that occurs at the core of communications media, which consistently obscure their material supports in the process of transmitting a message. The circulation of printed matter between city and dump is an articulation and reminder of these material supports. The dump is a site that registers the material excesses and remainders of print communications. Reading print through the dump, we discover that the landfill reveals the wastes of print through this accumulation. The disposal and disappearance of the city to the periphery even threatens to resurface in a moment of excess. In *Invisible Cities* Italo Calvino describes a metropolis, Leonia, which refreshes itself by discarding all its objects on a daily basis. The process of expulsion and accumulation grows to epic proportions, such that an increasing quantity of debris eventually looms at the periphery of the city, threatening a cataclysmic landslide. If Mr. Moore's room and the Fresh Kills Landfill are any indication of how these invisible geographies operate, then the landslide starts from within and without, a torrent erupting from spaces closed and open, unleashing paper that piles up finally to reveal the matter that is constantly disposed of in the process of communication.

2. A Brief History of Excess

Stepping back from the dump, it is useful to consider how paper became a unit of proliferation and accumulation. And how a survey of print may inform the excesses of present-day technologies, including electronics. As a medium of mass production and dissemination, print is arguably one of the initial and ideal media for the generation of communications in quantity. A certain volume of print is in fact necessary to meet "basic literacy needs": 40 pounds per person per year at minimum. The state of information overload that is so frequently referenced today can be traced to these qualities of paper: a medium to be measured in bulk, where literacy is calculated by the ton. In "Defining the Initial Shift: Some Features of Print Culture," Elizabeth Eisenstein reveals how central measurement is to print when she relays the degree to which print and literacy can be quantified and described as an accelerating condition. Addressing the history of print, Eisenstein traces the shift from script to print through measures related to quantity of items printed, as well as progress and acceleration within the print industry. Pointing out that the sheer quantity of reproduced material brought a population together in a way hitherto unheard of, she suggests, "the fact that identical images, maps and diagrams could be viewed simultaneously by scat-

figure 1

tered readers constituted a new kind of communications revolution in itself."[3] This revolution consists, in part, in categories of public (the masses) and media that are describable in terms of numeration—an indexical feedback that shapes our notion of culture.

While "paper production," according to Eisenstein, "quickened the pace of correspondence and enabled more men of letters to act as their own scribes," it also spurred speculation about whether the Devil or God may have been behind the excessive rates of production. "The fact remains," Eisenstein notes, "that the initial increase in output did strike contemporary observers as sufficiently remarkable to suggest supernatural intervention."[4] Indeed, part of the objection to print was that it allowed for quick and "hasty" manufacture, and in this rapid fire circulation, "errors and absurdities" might proliferate while "confus[ing] people's minds with an overabundance of texts." In this sense, as Roger Chartier indicates, "the advent of written culture in the West had to contend with the persistent notion that dissemination of knowledge was tantamount to profanation."[5] Where previously knowledge was held in an exclusive domain, it now ran rampant through multiple cultural circuits, whether high or low, Bible or training manual, print occurred *in quantity*. It was its amassing, moreover, that led to its contentious position at the time of its emergence.

Print, as a measurable medium, gave rise to methods that allow for tabulation, inventorying and counting. Even more, the numbers it tracked always increased as a sure sign of progress. The numinous power of print derives from its ability to generate and store in mass. Perhaps best illustrating this condition is the Hollerith machine and

3. Eisenstein, Elisabeth. "Defining the Initial Shift: Some Features of Print Culture," in *The Book History Reader*, eds. David Finkelstein and Alistair McCleery (New York: Routledge, 2002), 155.

4. Ibid., 153-154.

5. Chartier, Roger. "The Practical Impact of Writing," *The Book History Reader*, 125.

133
JENNIFER GABRYS

figure 2

punch card. This device was initially used to process the 1890 U.S. Census, by which time the Census had to keep track of over 70 million people—numbers that far exceeded human processing abilities. The mechanized paper punch card process allowed for speeded up tracking and recording of the burgeoning population. The punch cards were again used for the processing of United States Social Security payments in the 1930s, when the numbers of people to be processed ran into the millions. As the means of input and output, paper punch cards stored, calculated and retrieved data. A machine for computation, the Hollerith was a forerunner of the computer, which was to perform calculations on even larger stores of data. The migration of paper processing and tabulating to this machine capable of handling an abundance of material suggests that both paper and computers are inevitably transformers of data in excess. They manage the deluge while simultaneously contributing to it. Information processing, the management of masses of data, then develops from paper through the punch card and beyond. A modest moment in print culture, the punch card calls attention to print's capacity for measurement, accumulation and excess. It is ostensibly concerned with tracking and processing mountains of (often ephemeral) information.

What the PUNCHED HOLE can do

0 0 0 0	Add itself to another number	0 0
1 1 1 1	Subtract itself from another number	1 1
2 2 2 2	Post itself	2 2
3 3 3 3	Eliminate itself	3 3
4 4 4 4		4 4
5 5 5 5	Select itself	5 5
6 6 6 6	Produce an automatic balance forward	6 6
7 7 7 7	Cause a form to feed to a predetermined position or to be ejected automatically, or to space from one position to another	7 7
8 8 8 8		8 8
9 9 9 9	Cause a total to be printed	9 9

figure 3

Of course this model holds for other types of print that do not explicitly address tabulation, measurement and computation, whether newspapers or tabloids.[6]

Marshall McLuhan surveys print as a unit of production in *The Gutenberg Galaxy*, where he discusses the rise of printing as a technology of uniformity and infinite expanse. He remarks, "The concept of the infinite was not imposed upon us by logic. It was the gift of Gutenberg. So, also, later on, was the industrial assembly line. The power to translate knowledge into mechanical production by the breaking up of any process into fragmented aspects to be placed in a lineal sequence of movable, yet uniform, parts was the formal essence of the printing press."[7] McLuhan characterizes the processes of accumulation in mechanized industry as "manufacture by mono-fracture, or the tackling of all things and operations one-bit-at-a-time." Proceeding bit by bit, he writes, "is the challenge that has permeated all aspects of our lives and enabled us to expand so triumphantly in all directions and in all spheres."[8] To this end, the capacity of print for infinite expansion found expression in early computer models. In 1937, the British mathematician Alan Turing created the "universal machine," an imaginary device that led to the development of the personal computer. As a computation system, the machine depended for storage upon a paper tape of infinite length. So long as it was fueled with an endless if abstract supply of paper, this machine was capable of

6. In fact, of all the paper types in landfills, newspapers consume the most landfill space.

7. McLuhan, Marshall. *The Gutenberg Galaxy: The Making of Typographic Man* (University of Toronto Press, 1962), 116.

8. McLuhan, Marshall. *Understanding Media* (Cambridge: MIT Press, 1994 [1964]), 73.

continuous computation and information production. The recent history of information processing is replete with similarly quiet assumptions about limitless resources and capacity for production, assumptions that have only come to light as information has reached a state of overload. In the example of Turing's infinite paper tape we see how measurement holds the delirious potential of the immeasurable, of growth and progress beyond imagine.

fig. 4

The computer has even accerlerated the processing and production of printed matter. It is a device ensuring that far from becoming a "paperless society," we have instead realized new means for drowning in masses of paper. In *Rubbish!*, William Rathje and Cullen Murphy counter the notion of a paperless society by taking stock of exactly how much paper can be exhumed from landfills. They find that paper has increased rather than decreased, and write, "it is obvious by now that computers, far from making paper obsolete, have made it possible to generate lengthy hard-copy documents more easily than ever before. A computer with a printer is, in effect, a printing press, and there are now fifty-five million of these printing presses in American homes and offices."[9] Office paper as well as packaging paper, telephone books and newspapers have all contributed to the steady if not increasing amounts of paper in landfills. In garbage, Rathje sees a key component to contemporary material culture. Much as archaeologists study the relics of the distant past, Rathje unearths the refuse of the recent past to get an accurate gauge on consumption. This practice, termed "garbology," examines cultural phenomena by linking discarded artifacts with consumption patterns.

3. Disappearing Geographies

According to Garbologist William Rathje, these dumps are our modern ruins where, like archaeologists studying material remains, we may conjecture about recent events. Prior to its closing in 2001, Fresh Kills was the world's largest landfill. And as Rathje points out, it was also "one of the world's largest monuments." He notes that when operational it "consumes 2.4 billion cubic feet of space, 25 times the volume of the Great Pyramid at Giza."[10] Opened in the 1940s, Fresh Kills received as much as 29,000 tons of trash a day, adding up to 50 million tons over 50 years. The landfill was a project set into place by Robert Moses, the former New York City urban planner. Benjamin Miller, author of *Fat of the Land: Garbage in New York*, documents how Moses attempted to counter protests to the proposed landfill by suggesting that "only papers, refuse—clean fill"[11] would be dumped at the site. All manner of debris was eventually trucked to the landfill

9. Rathje, William and Culleen Murphy. *Rubbish! The Archaeology of Garbage* (New York: HarperCollins, 1992), 103.

10. Rathje, William. "Once and Future Landfills," *National Geographic Magazine*, Volume 175, No. 5 (May 1991), 120.

11. Miller, Benjamin. *Fat of the Land: The Garbage of New York—The Last Two Hundred Years* (New York: Four Walls Eight Windows, 2000), 206.

figure 4

in order to stabilize the land for road construction. And paper did indeed form some of the primary fill for this project.

Rathje, operating under the auspices of the Garbage Project, made a project of excavating borings from this and other landfills. He has studied Fresh Kills as an "archaeological record of postwar America,"[12] by studying core samples taken from 100 feet down into the garbage. Because the landfill is sealed off to light and oxygen, objects contained within are often perfectly preserved, and newspapers dating back to the 1960s may be still legible. In the process of excavating to reveal exactly what makes up the landfill, Rathje has discovered that "the largest 'invisible man' lurking inside landfills is paper. It is also the fastest growing component. From 35 percent of volume in 1970, refuse paper has burgeoned to 50 percent."[13] Rathje has found that computers, rather than introducing a paperless society, actually increased the amount of paper in landfills.[14]

12. Schoofs, Mark. "A Landfill That Tells Eight Million Stories Now Has One More—Fresh Kills Is Reopened to Hold Remains of the Twin Towers; Raking Through the Rubble," Wall Street Journal, A.1.

13. Rathje, "Once and Future Landfills," 122.

14. Schoofs, A.1.

In many ways, paper ushers in a culture of disposability. As Susan Strasser writes in *Waste and Want: A Social History of Trash*, paper products became a mark of cleanliness and efficiency. From toilet paper to paper cups and paper packaging, paper announces itself as a throwaway material medium.[15] In New York City, millions of people, like the inhabitants of Leonia, perform their daily rituals of discarding. In this process, print culture becomes printed matter, a raw material that is stripped of its ephemeral significance to pile up in remote landscapes. Such a transformation to printed matter performs an entropic slump, where texts lapse out of the state of information to register as wasted material.[16]

In many ways, the quantity of print circulating then defines eventual zones of accumulation. Sites of active reading and display give way to the more workaday gutter and towering landfill. Mounds of garbage wait to be hauled off city streets, and litter is swept away only to resurface on the periphery as heaps of discarded language. Jody Baker suggests that "the mountains of trash outside every city and town begin to signify the historical limits of industrialization." Such limits mark moments of excess, and indicate historical, political and economic thresholds. While waste at one time referred to wastelands, or in other words, space that was uncultivated, or "that which existed *prior* to the process of production," waste now has migrated "across the production process to its other end" to become the "waste product." Waste, in this sense, requires a spatial and material focus. Baker suggests that "waste is a spatial category; it is produced *in place*; it is realized only in its materiality."[17] The wastes of paper—and communications media more generally—are perhaps revealed most clearly in the place of the landfill. The engine of growth and excess that is central to paper contributes not only to the proliferation of information, but also to the ongoing construction of peripheral wastelands.

Print culture entails not only the production of space, but also the consumption of space. Print and its wastes form boundaries between city and periphery, inside and outside, which as Baker notes is exactly where waste must be placed. Printed matter is extracted from the city in an outward flow to the periphery. For many years, Fresh Kills Landfill on Staten Island was the "nonsite" where so much printed matter was sent. Such an extraction of print from the city is a way to erase and destroy stores of information in order to clear way for additional data to emerge and pile up. Like the stacking up of "yesterday's newspaper," as Katherine Hayles suggests, "the residue of previous information fills up space that must always be emptied."[18]

15. Strasser, Susan. *Waste and Want: A Social History of Trash* (New York: Henry Holt, 1999).

16. This notion is articulated through Robert Smithson's 1966 artwork, *A Heap of Language*, as well as his 1967 essay, "Language to be Looked at and/or Things to be Read".

16. This notion is articulated through Robert Smithson's 1966 artwork, *A Heap of Language*, as well as his 1967 essay, "Language to be Looked at and/or Things to be Read".

17. Baker, Jody. "Modeling Industrial Thresholds: Waste at the Confluence of Social and Ecological Turbulence," *Cultronix* 1, no. 1 (1994), http://eserver.org/cultronix/baker. Numerous writers address the limits and boundaries of waste. For example, see Mary Douglas, *Purity and Danger* (London: Routledge, 1966).

18. Hayles, Katherine N. *Chaos Bound: Orderly Disorder in Contemporary Literature and Science* (Ithaca: Cornell University Press, 1990), 47.

figure 5

Figure 4-C. Interstate traffic in garbage has grown increasingly heavy and complex. In order to remain comprehensible, this map does not show the movement of garbage out of New York and New Jersey, the two biggest garbage-exporting states in the country. New York's garbage is trucked as far away as New Mexico.
SOURCE: National Solid Wastes Management Association

The city, as a zone of constant media production and consumption, must be cleared out. It is a zone of continual disposal, and its geographies disappear repeatedly. Disposal as a mode of circulation reveals a process of dematerialization, where waste is dispersed and made invisible: a performance of disappearing geographies. With the closure of the Fresh Kills Landfill, New York City garbage is now trucked as far away as Indiana and New Mexico. Printed matter floats in barges, is processed, transferred, collected, distributed and trucked across the continent. Between waste and wasteland, the tide of communication swells and the disappearing act continues. But the wasted matter always returns.

fig. 5

Experiments
in Architecture

Brandon LaBelle

EXPERIMENTS IN
READING *EXPERIMENTS
IN ARCHITECTURE*

Approaching architecture through writing leaves me wondering—what do writing and architecture have to do with each other? What might they have in common and what might they say to one another? While architecture is without a doubt resolutely bound to other material and media than concrete or wood, the act of writing architecture seems to have a special history, revealed in various literatures, theoretical inquiries, and textual strategies. From recent classic works such as Michel de Certeau's *The Practice of Everyday Life*, which overlays literary motifs and theories onto spaces of the city with the aim of usurping existing structures. Such moves seek to uncover or engender the potentiality of pedestrian life to write or script the city. Or, in Georges Perec's poetic notations generated through observations of streets and neighborhoods, texts partially produced or impelled by the very structures of the built: *Species of Spaces* is equally species of writing, leading a reader through labyrinths of subjective attention and reflection. The city as text finds its microcosm in the notion of buildings as bodies: the built as containing the proportions of the human body, as a corresponding geometry, or buildings symbolically expressing a given ideology, memorializing figures of history that lend articulation through material stability to the cultural values of a given society. Such aspects in turn highlight architecture as a text deciphered through conscious and sub-conscious acts of reading. The built thus seems laced with textual strategies and understanding, lending in turn to acts of writing in which the built functions not as backdrop but as foregrounded materiality. As in structuralist filmmaking where the very media of film is investigated through film itself, hinging form and content around an architectonics of vision and filmic matter, writings infused with the

built sub-textually form themselves around spatial understanding, creating narrative through architectures of reading. This goes beyond the simple structure of narrative, which operates as an embedded tectonic device (as in metric poetry), to the formation of texts that ultimately bring such structuring to the surface of content, as in Robbe-Grillet's *Labyrinth*, whose textual field is partially delivered through motifs of repetition, spatial description, and a general atmosphere of the built. Such works point toward an already existing conversation between writing and architecture, text and the built, however circuitous and idiosyncratic, a kind of history of their twining that seems to demand a kind of second look. For such relations may further remind us that to write seems inherently to construct, through syntactical and grammatical craft, a world that is at one and the same time ideal and actual; and that notions of embodiment or inhabitation, and their imagined architectures, do not occlude the practice of reading and the spaces of the mind: who would deny the ways in which reading occurs through modes of inhabiting the space of the page?

It is with such notions that I pick up the book *Experiments in Architecture*. And by which I approach this writing (or, this construction on the page). Hence in opening the book's pages I am not only reading, but also entering an architectural hall of mirrors in which text and space refract and diffuse their respective borders, involving my own presence through a collapse of distance. For the writing (my own) that refers to a writing (the book) that itself refers to an architecture that in most cases is primarily conceptual and in itself text-oriented (which the works in *Experiments in Architecture* are) must inevitably become awash in its own discursive euphoria, which to my understanding is the partial appeal and thrust of *Experiments in Architecture*: the very word "experiment" seems to promise as much. It is this promise that I recognize as my own motivating point of origin: from within this hall of mirrors, the book *Experiments in Architecture* just by title alone sparks my interest: it says, I am for you. It promises to expand or titillate, through concrete information and documentation, the very fantasy I have of an experimental architecture, and the opportunities it may (or should) generate. Immediately, the word "experiments" leads language to a peripheral edge: to be experimental is to pose challenges, to engage critical practices, fostering new paths toward exchange. Right from the beginning, the book seeks to disengage from the law. Thus, I am prey to the book's title – already I am inside the labyrinth of its experiential culture of words, as the book bends the rule of language, promising to tease the delights of discovery and spatial imagination. In this re-

gard, discursive euphoria is also the very thing that leads us off the page and that inspires forms of living with reading, inhabiting spaces partially built from the promise of the text.

The overall thrust of the book seems motivated by an interlacing of experimental words and experimental spaces, making text sympathetic to the very forms of practice being discussed. From diaristic stories of studio practice (Cedric Price, Bruce McLean, Matty Pye & Richard Wentworth, Ben Morris) and concrete-esque poetry and story-telling that engage the trials and errors of experimentation (Kevin Gray, Nicholas Royle & David Rosen) to pursuits of pedagogy viewed from a general platform of liberal idealism (David Greene, Feliks Topolski) and the motifs of drawing and graphic mark-making inherently infused with a degree of process, beyond the intentions of appealing to professionalism (Sand Helsel, Dickon Robinson, Roger Zogolovitch), all echoed in the book's stark black and white design (except the gold smudge emblazoned on the cover)—the domain of text here operates according to a sign of radicality. This sign is already in the title, but more so, supported and graphically made explicit through the gold smudge occupying, as if in defacement, the book's cover.

The gold smudge is a visual cue that the book is an object of use—experiential, material, forged from the grit of the street and the muddiness of the studio, it is a work in itself, in progress and always open to appropriation and transmutation. An object par excellence of the fantasy of experimentation. Thus, it seems, to read *Experiments in Architecture* is to dream upon the very promise contained not only in the title but also in the smudge. The smudge is the ill-defined that is all too defined: it speaks through the language that is itself partially against language. From the very instant, the cover speaks as a processional device, forging new paths through an indication or sign of what it means to practice: cutting edge here is iterated through gold smudge.

The book comes to me as a partial object fulfilling an inherent longing for the promised land of experimental architecture. That is to say—Already I want to use it, to dip into the smudge expressing the very charm of the book—to further the promise expressed by the book's own self-defacement. Thus, from here use on some level operates as abuse, and reading equates with acts of construction: my reading of the book, as a foray into the architectural *I take it everywhere I go. I travel with it. It becomes a partner to the comings and goings defining a day; a friend to the queries taking place within random locations. It functions as a support, by its suggestiveness, to the demands and productions of working life. Part-baby-blanket, part-companion, part-entertainment, we are inseparable.*

It finds a place in the environment—I give it its own space; it takes root.

Experiments
in
...tecture

hall of mirrors spawning reflection upon reflection, is enacted through vandalism in which scanning the page leads to refurbishments, sifting its content generates additions and subtractions, reading its articles spawns forms of appropriation and ultimate citation. In this way I incorporate its pages onto the surface of this one, smuggling in *Experiments in Architecture* through using it, and subsequently, using this one: my writing then is a form of graffiti, these words an echo of the gold smudge found on the cover of Experiments in Architecture.

To return to the paradox articulated by Bernard Tschumi in his book *Architecture and Disjunction*, which is based on an ongoing tension between what Tschumi defines as the "architectural rule" (pyramid) and the "labyrinth of experience," or between concept and actuality, I want to reopen Tschumi's answer of an "architecture of excess."[1] For Tschumi an architecture of excess incorporates through a philosophical erotics the paradox by not seeking an escape route, but by embodying its inherent disjunctiveness. Piercing the architectural rule with openings or fissures, and spanning the experiential with an amplification of multiplicity by way of the labyrinth, an architecture of excess may point to the necessity of maintaining the architectural rule while seeking the idiosyncratic potentialities of being in and amongst space. For what becomes apparent by following the paradox is that it is not about naming the ills of architecture, or pointing out right from wrong, but locating the relation of rule and its usage. That this relation is paradoxical does not require a desperate leap forward into the void, or a jump back into primary nostalgia of an imagined origin, but rather a negotiation through built form. This plays out for Tschumi in his now seminal work for the Parc de la Villette. Commissioned in 1982 and constructed in 1987, Tschumi's park design is based on strategizing an incorporation of an architectural rule, here mapped out through a strict point-grid lay out according to which the pavilions, or what Tschumi refers to as "Folies" are located at 120 meter intervals. Lacing the Folies a series of Lines or Coordinates are inserted crossing the park in two intersecting axes along which active pedestrian movement occurs. Such a lay out for Tschumi aims to present a clear structure to the otherwise vague terrain of the park, allowing orientation and navigation while also stimulating discovery. In addition, each Folie is essentially a 10 cubic volume (each three storeys high) designed as "neutral" spaces in which any number of programs could be applied. Seeking to stimulate individual trajectories and discoveries, the Folies act as empty shells to which functions could be inserted, and also transformed over time, from cafes to libraries, meeting points to exhibitions (upon a recent

1. See Bernard Tschumi, "The Architectural Paradox" in *Architecture and Disjunction* (Cambridge, MA: MIT Press, 1998).

visit, one of the Folies is now a Quik Burger). In addition, the Folies themselves are designed half-way between sculpture and architecture, consisting of primary shapes riddled with excessive flourishes, from staircases leading to mezzanines, gridded I-beams framing nothing but pure view, or ladder-like objects shooting into the sky (reminiscent of Constant's labyrinth of ladders), all excessively beaming in bright red.

Tschumi's park stands as exemplary of deconstructivist architecture by being designed around its own theoretical strategies that seek the intrusion of outside influence or force: the Folies, and the design in general, operate as partial-objects inviting into the frame of the architectural rule, the labyrinthine movements of public intervention or accentuation, and the potential articulation of multiple meanings. Further, the work seeks to partially undo architecture from within by escaping both a notion of essence (a unified, single meaning) as well as utility, fragmenting a sense of the domestic or monumental into a set of indeterminate vessels. The Parc, and the Folies, set up an extended spatiality that resists forms of enclosure, symmetry, verticality, constructing instead lines and coordinates that usurp totalizing views. Such interlacing and partiality echoes Tschumi's proposals for alternatives to the architectural paradox, generating spatial articulation through an investment in what we might call a performative dialogue with the park itself as a space of multiple actions and activities.

I open up Tschumi's thought and work so as to stage the very tension embedded in any form of cultural production and its ultimate usage, whether that be architecture, or music, film, or a book. The engagement with cultural work is not only about being curious as to what the work contains or says, but ultimately how one might incorporate, through acts of usage, the work: what does this music say to me and how might it generate opportunities for bringing it into my life, into the rhythms of life's journey; or, how might this book, and its information, its writing through ideas and narrative features or voices, echo into the sub-conscious, finding its way into the tiny vessels of thought and feeling so as to lead me to see the world in other ways. In short, how might I come to embody the work's lessons, turning back to the space of production an active echo. Such questions lead to the elaborate processes by which culture in itself lives and breathes, taking shape through an oscillation or exchange between making and receiving, and their ultimate integration. Yet architecture holds a special relation to such integration, for it performs such work on an intensely public level, designing the built environment and thereby coming to partially define the experiential itself. Whereas architecture unequivocally ruptures and defines a public landscape,

the book and subsequent acts of reading come to the individual through private moments: moving into the page, following the text's manoeuvres, encountering the embedded viewpoints and perspectives, voices and figures, occurs by being private. Thus, the cultural work of architecture and writing seems to occupy the extremes of a spectrum by which usage takes place. McLuhan's established criticism of the isolated literate Westerner is founded on the recognition of reading as unquestionably private (and therefore asocial).[2] Curiously, McLuhan further locates a prototypical public experience in "acoustic space," for acoustic space is reliant upon forms of sharing that implicate individuals into being public. Hence the spoken word and the thrust of orality in general for McLuhan undermine the isolated literate Westerner, stitching him back into the social fold by leaving the page behind. Yet architecture teaches us methods of reading that are reliant upon both forms of being public and being private. The symbolic expressions found in civic buildings act as stable references in an otherwise volatile landscape—ideal markers stapled to the ruptures and movements of social and political events; such iconic buildings are readable as public texts, garnering social values into forms loaded with meaning. These more obvious methods of public reading of architecture trickles into minor readings, where more mundane buildings are expressive of local values, vernacular bonds, forgotten histories, and personal ideals. From houses to schools, post offices to cafes, architecture publicly generates forms of reading that nonetheless require strategies of interpretation, some more conscious than others, some more private than others. In this way, we might locate reading and writing, occupation and architecture, as integrated and subsequently relational to larger questions of embodiment, usage, and cultural expression and interpretation. Whereas books generate community through their circulation into private lives, often written from the viewpoint of the individual struggling in the field of public relations and searching for unknown colleagues and friends, architecture occupies the public landscape through powerful expressions that are often subservient or in negotiation with larger political and cultural forces and that potentially undo means for personalized bonds. It seems though that books in turn become forms of monuments to given cultural periods, acting as gathering points upon which a whole generation may find identity; in addition, we might locate architecture in its attempts to become personal, through instances where it opens itself or exposes its forms and functions to the everyday body, seeking a mutual exchange in the formation of an as yet determined story.

2. See Marshall McLuhan, *Understanding Media* (London: Routledge, 2002).

Such thinking may recall earlier instances, as in the work of Peter and Alison Smithson, and the general wave of New Brutalism. Seeking to make an "architecture related to reality" the Smithson's developed a spatial and philosophical program dedicated to preserving an inherent reciprocity between form and function. Functionalism for the Modern Movement was placed not in relation to a projection of pure geometry and ideal form, but against the hard-edged reality of post-war Britain. By doing so, the Smithson's attempted to integrate the logic of Modernism's material language into the specifics of real conditions. Here, the architectural paradox was to find resolution by relying upon notions of "as found"—the as found passions articulated by the Smithson's, and others revolving around the Independent Group in the 1950s, were a way of taking note of reality in a radical way leading to a rugged materiality, directness, and immediacy, where the relation of form and function, concept and use, may find balance on the fulcrum of reality.

The stripped down edginess of their early projects, such as the Hunstanton Secondary School (1954), or their Upper Lawn House (1962) suggest that a certain authenticity of built form would alleviate architecture's tendencies toward prescriptive programming: exposing structural elements, reducing unnecessary ornamentation, the New Brutalism sought to be both architectural concept and its ultimate usage at one and the same time. Yet it seems to do so by supporting both the physicality of being with space as well as the ways in which consciousness as to one's place within larger material cultures are interwoven. In this sense, inhabiting architecture may be found in the expressiveness of corporeal presence equally with how we are also always reading space: physical presence is in turn

Sometimes a picture contains a thousand words, other times it contains just enough: the time of reading is a productive filter: scanning the page, taking one word at a time, structures the pace of knowledge according to a steady, slightly banal and tedious momentum: I must start with the first page, then move onto the next, and so forth (there is no skipping ahead!). Such momentum though in itself allows one to live with reading: I carry this book with me, and in doing so I come to live with my reading of its pages: book and place become intertwined, thus in picking it up now, after having completed it, I recall the places in which my reading took place, the environments by which all its textual dynamics were incorporated into my own rhythms and knowing; how book and place embed themselves on the ways in which living takes place, and finally, ultimately, reverberate out, into actions which somehow express the reading of the book: I put the book back, not on the shelf, but at the place where its pages were devoured.

153
BRANDON LABELLE

thoughtful awareness. Such moves may find completion in architectural deconstruction in so far as embodied experience is refuted as an essential, primary core of spatiality: the body does not represent fully the completion of an ultimate architecture. In turn, functionalism too often serves the larger values given expression in technocratic efficiency, concealing what Rosalyn Deutsche terms a "spatial politics" behind a language of utility.

What Tschumi's Parc supplies is recognition that the event of architecture, while in its most experimental and avant-gardist move toward nurturing embodied experience, in turn supports the conceptual and cerebral processes by which we come to live with architecture. Instead of forcibly supporting the notion that usage and experience must always equate with the body, in acts of corporeal usage, Tschumi seeks to appreciate on what level the imagination inhabits space. For to use the Parc de la Villette is to also imagine possibility. Tschumi's architecture of excess is thus an attempt to exceed pure form without completing embodied trajectories: the Folies are never really enough, and at the same time, they are too much.

Like Michel de Certeau's manuscript of the city, which engages the pedestrian (labyrinth) against the grid of the urban plan (pyramid), experience is partially imagined through notions of place. Finding routes is about speaking out, through vernacular tongues, the personalized trajectories of everyday life, thereby appropriating the given language of the city to fashion self-styled adventures. Errands are thus opportunities for discovering back alley debris, or detouring to visit neighbors, dropping by to offer best wishes on their wedding, or hitting the bar for a quick snifter. Such moments give rise to an expanded sense of being in place, by leading one outside routines toward minute instances of freedom: personalized expression is thus locutionary as well as spatial. As Rosalyn Deutsche furthers, social relations are manifest in spatial forms. That social relations contain their own micro-instances is manifest in the spatial definitions one gives to a single day. What Deutsche ends up with, as part of this equation though, is the ultimate manifestation of a spatial politics, for sociality contains the tensions of being in place, situated and specific to the realm of the law and its opposition.

The architectural paradox—Tschumi's dichotomy of the architectural rule and the labyrinth of experience—has embedded within it the tensions inherent to sociality: one may be said to always be negotiating between rule and the experiential, between a given form and its application. What I am seeking though are instances where spatial forms appear not solely as physical manifestations, but as poetical textures, as acts of reading yet a reading that is inherently

whimsical and productive: a form of embodiment and inhabitation by which interpretation is partly enacted and partly inscribed. This may run the risk of supporting the very thing that Henri Lefebvre sought to combat in his *Production of Space*. As Lefebvre's argument runs, forms of readability and visibility within architecture must on some level always participate in and be subservient to the greater force of Capitalist values and economies. To collapse the city into a series of signs would be to undermine human experience according to a logic of the Spectacle, for the "rise of the visual realm entails a series of substitutions and displacements by means of which it overwhelms the whole body and usurps it."[3] Turning architecture into pure optics or signage (as in the case of Venturi, whom Lefebvre cites) would be to force it into a role of advertising—building as billboard—and thereby undermine individual presence and agency. In contrast though, Lefebvre's argument seems to partially overlook (literally) the process of reading as inherently embodied and productive (in his sense): while reading performs through what Lefebvre terms "abstract space" (the space of the page is a quintessentially abstract one, if not the absolute) such abstraction may in itself perform against or outside the grammar of established codes (Capitalist and other). That is, it may be on the level of the readable that one might locate and support agitations onto the built, rather than outside and in the field of what he calls "the body."

Tschumi's Parc is thus spatial, defining through physical form a potential for discovering routes and experiential exchange, and also poetical images written through already recognizing architecture as graphic and legible, and reading as embodied manoeuvres. In this regard, the built is contentious precisely by being physical (territorial) as well as textual (law). It writes by building that is in turn grammatical, semantic, and thereby potently imaginary. It's this poetical that I see as a means for reading architecture, and for an architectural reading that may supply us with a sense of approaching the built with criticality while also allowing the body to escape the demands such criticality (as a legacy) seems to place upon it.

Gaston Bachelard locates such relation, emphasizing spatiality and its experiential presence through poetical writing, uncovering a spatio-temporal mythology of archetypal forms or coordinates. In his *The Poetics of Space*, such mythology is located primarily through the notion of the home, which features as a transcendental motif. "All really inhabitable space bears the essence of the notion of home,"[4] Bachelard claims. What marks the work is a continual referral or reliance on poetic text, and more so, the poetic as an overarching value. Interweaving poetic texts and citations, he locates the poetical by

3. Henri Lefebvre, *The Production of Space*, trans. Donald Nicholson-Smith (Oxford: Blackwell, 2000), p. 286.

4. Gaston Bachelard, *The Poetics of Space*, trans. Maria Jolas (Boston: Beacon Press, 1969), p. 5.

reading descriptive and associative instances of spatial expression, from images of attics to staircases, windows and vistas to candle-lit cupboards and gleaming surfaces, found in an array of poetic sources. The poetic image comes to articulate a personal cosmology, whereby Bachelard dreams upon spatiality so as to redefine a relation to being in the world—"The great function of poetry is to give us back the situations of our dreams"[5]: writing and spatiality intermix in an allegory whereby presence is both a form of consciousness as well as a topography (a place of writing). Such personalized vocabulary carries with it an archetypal, metaphysical aura, in which spatiality may speak to larger universal experiences or knowledge—it seeks the mythical through the materiality of being in space, criss-crossing in and out of dimension and scale, the movements of text read through the place of being present, a space (of) reading. While such thinking is seemingly unfashionable in relation to architectural deconstruction, what Bachelard's work opens up is also other means of locating spatiality. The poetical for Bachelard is precisely where architecture may become personal while also engaging with larger questions—how it might appear as or generate a series of openings found within the very sense of enclosure. To inhabit is to fashion self-styled languages of usage, while recognizing how spatiality is beholden to a greater arena, whether mythic or cultural.

The poetic from this perspective is absolutely productive (poiesis), rather than passive; generative of negotiations across borders, impasses of thinking, the poetical brings the imagination towards the unimaginable by supplying a route: "the poetic image is an emergence from language, it is always a little above the language of signification"[6]—for Bachelard this route is found in instances of drifting or reverie, for to daydream is to be profoundly situated at one and the same time within immediate place as well as the imaginary; reverie is an intermixing of the sacred and the profane: flushed with the aura of the religious (it edges up to rapture, transcendence, and the shuddering of consciousness in the face of the divine…) while remaining dependent upon immediate detail, the fabric of the local, and all the mechanics of the banal: it brings one into reality according to a logic of erring. The poetical in this regard may contrast further with what Lefebvre terms Modernism's triad of "readability-visibility-intelligibility" that for Lefebvre "contain so many errors."[7] The topo-analytic drifts of Bachelard reads space by harboring their own embedded errors: in this sense, the Bachelardian spatial text might be understood to be one based on mis-reading, for reverie is in turn that which slips

5. Ibid., p. 15.
6. Ibid., p. 13.
7. Henri Lefebvre, *The Production of Space*, p. 96.

off the map of intelligibility, (like the poetic image, it is a little above the language of signification) to form other semantics precisely inside the powerful devices of language and architecture.

The work of the daydream for Bachelard is spatial and meaningful, embodied and imaginary; it builds an unseen yet potent bridge between interior and exterior, according to another mode of being in place, and reading, one that must be understood to slip in and against language, teasing sensibility with the unconscious (one is not in the space of nocturnal dreaming, in the throes of the unconscious, but rather is operating within the day, drifting for a moment against the tremor of an unspoken imaginary). It is a slight rapture puncturing, in the light of day, consciousness with tiny tremors; it is not the content of night dreams, but their situations; it observes the invisible tracings, like secret blueprints, to the visible contours of the home. Such thinking stitches together acts of reading with spatial presence leaving room for readability as means for producing space.

Architecture of excess, the poetic image, usage and abuse—such thinking seems to circulate around negotiating between production and consumption, regulating such dichotomy through embodied gestures, acts of inhabitation, reading, interpretation and appropriation. Living within, interpreting through, putting to use, such acts are given currency in and against the seemingly more conceptual gestures of architectural planning, searching for methods and attitudes that criss-cross the divide, spiriting hybrid notions: Tschumi's Parc is embroiled in obsessive skirmishes with material form—like a mad carnival of digressive poses, each Folie bespeaks an inher-

Reading in public, occupying the sidewalk, book in hand, movements of eyes mirror movements of bodies on the go: he is engrossed in the page, oblivious to others, allowing the rhythms of the street to weave into the text, and the motion of left to right, down again, then left to right, down again, to finally turn the page, to begin anew, fresh with the dynamism of being inside another's thinking – the mind is turned away from location, just for a moment, entering the palace of writing: he reads, and what he reads is a book on architecture (at least that is how it seems). Standing upright, leaning against a pole, on the corner, where others are waiting, the empty space behind opened up just for a moment, until finally, inevitably the flow of bodies will come flooding in to fill the street, to crisscross and intersect in temporal passing, exposed and exposing through secret and delicate glances and brushings, of elbow to elbow, eye to eye... They read the city like he reads his book. Where is the text then, in and amongst the scene, in the pause between movements (in this hall of architectural mirrors)? And who is the reader? Him there, me here, you over there?

ent tendency toward the outlandish while maintaining a relation to functionality, slipping between architecture and sculpture, graphics and occupation, finding parallel in what Anthony Vidler refers to as "mutant form." In discussing the artist Rachel Whiteread, Vidler characterizes her work as "mutant" derived by recognizing an oscillation between form and function, or art and architecture, in her work. Vidler seems to locate another notion or relation to function in Whiteread's projects, as they radicalize the architectural by skirting the assumptions around how forms perform. For instance, her *House* (1993-4) project installed in the East End of London set out to linger over the disappearing community of Victorian terraced-houses in Bow, creating an uncanny monument by making a complete cast of the last remaining house on the block destined for demolition. A ghostly block of concrete standing freely in an open field, the work generated a plethora of media attention and opposing opinions, from casting it as disrespectful to the local community and obstructing the final clearance of the row of houses, to championing it as a new form of monument, *House* straddled a tense line, and in doing so, offered a meeting point of disparate views. For Vidler, part of this operation occurs on the level of form and function, for "the Whiteread memorial is after something different from architecture… Her project looks to the always uneasy status of the monument within architecture, its wavering between art and use."[8]

*Thus, mutant form functions partially as a medium or fulcrum upon which complexity may find articulation, galvanizing dichotomous or disparate elements into a single object: it functions as a production of space that is inherently polyphonous. In this case, polyphony built in concrete and riveting public opinion (within the first month of its appearance the House of Commons held a session to debate the work, ultimately leading to its removal). As Vilder continues, "Whiteread undermines this binary problem [of art and use] by deliberately confusing sculpture and architecture,"[9] forcing us to search for a new means of comprehending this other symbolism. For Whiteread's work is unsettling precisely on the level that it presents an architectural gesture that is entirely symbolic, and as such difficult to gauge: *House* refuses to sit comfortably on either side of the sculpture / architecture divide, making claims on the architectural through totally occupying the exact scale of the original house—by being a replica (or, we might call it a Replicant)—while shifting one's ability to clearly identify it as pure monument. In this sense, we might call *House* a poetic image in so far as it calls us to consider the archetypal vessel of the Home while producing an uncanny relation to the specifics of its location. In this regard, *House* is a partial resistance to the symbolic:

8. Anthony Vidler, "Full House: Rachel Whiteread's Postdomestic Casts," in *Warped Space* (Cambridge, MA: MIT Press, 2003), P. 149.

9. Ibid.

BRANDON LABELLE

rather than fulfilling meaning through a declared syntax of identifiable form, House rests unsteadily upon the field of meaning: it makes no declaration, rather it materially prolongs the life of a building, allowing it to gain in volume through its dead silence.

House is physically uninhabitable, a shadow image of its original that is also totally solid; a literal block refusing to be moved, stubbornly deferring the final removal of the community—it acts as a supplement in this regard, by being an excess, a left-over, something filling the margins, occupying that which must be vacated, while revealing because of this an integral lack within the original, the street, the city, the very project of removing the houses, and the attempts to reform and replace the existing community and its spaces (as part of the government's long-standing policy of "improvement"). House brings into question both personal relations to what we imagine home being—to relate to this block of plaster, as an image and as a supplement, a mutant—while stitching this into a larger cultural and political environment related to history and governmental policy. Thus, House as synthesis makes a confrontation between nature and history, demanding some negotiation between the two, a kind of concert of opposing forces: for House refuses personal identification (one cannot inhabit the sacred space of this home, to imagine possible residence) while in turn imposing, because of this refusal, a confrontation with forces that come to act upon the home, from outside its seeming nature. "The line drawn by a house is not that between what appears as an inside and what appears as an outside, but the less clearly defined and much more convoluted one between the visible and the invisible."[10] House harbors force precisely because it is readable in this way (it negates reverie, and the cosy warmth of domestic space—Gaston would have nowhere to drift here...), acting as a document of particular events by solidifying conflicting views, forcing us to read spatial form as implicated within greater forces of memory, community, imagination, all of which find uneasy balance. Whiteread's House is a galvanizing rupture onto the ideal of home, both supplying questions and answers as to the visible and invisible forces that make the domestic (which contains domestication) political. For House delimits the values that appropriate "home" as the site of safety and control (house law) by ironically limiting—blocking out—the ability to gauge what is inside and what is outside.

The mutant form is thus a tense synthesis: part-recognizable and part-alien, part-poetic image and part-political act, the mutant is catalyst for both alarm and fantasy, for it hijacks the conventional features of a given language—whether architectural, cultural, or sculptural—for

[10] Mark Wigley, *The Architecture of Deconstruction: Derrida's Haunt* (Cambridge, MA: MIT Press, 1997), p. 131.

164
EXPERIMENTS IN READING
EXPERIMENTS IN ARCHITECTURE

"Has anyone seen my book?"

I just can't seem to find it

Experi
in Arch

the purposes of locating previously inaccessible compromises with the other. The mutant hence incorporates or inserts into the mainstream body (convention) characteristics partially alien, partially unspeakable, acting as both indoctrination of the other (it allows the previously unspeakable into conversation) and immunizing force for those on the inside (creating a bridge toward acceptance or dialogue). Whereas Whiteread's *House* brings home the murmurs of lost lives, making them legible on the surfaces of space and upon a street in London, Tschumi's Folies become screens for the projection and enactment of a spatial play. The mutant lays the foundations for cultural negotiation through making claims on form and function.

Inevitably, as with every book, one must close the cover, set it down, and leave it behind… But my reading wants to continue: I bring the book with me, to the toilet, to the studio, to the kitchen… I try and incorporate it into every action or task needing to be done: cleaning, cooking, washing… But, the book doesn't quite fit in: it gets in the way, it agitates my movements, trips me up, yet contributing to my movements a supple invasion of words—I read while walking, looking up from the page when crossing the street, keeping my finger between the pages to hold my place, then reading again, on the other side, my pace in tune with the flow of words, as a form of reading in place; the book accompanies between onion chops, soup stirs, and beer sips. The incorporation opens up to how form and function, rule and use, reading and doing, cross-over: excesses, poiesis, daydreaming, becoming-mutant, operate as pirate economies by which mind and body take up residence. Making an object out of the book, it becomes part of the materiality of place, participating in the actuality of forms and their functions, gestures and their involvement in communicating: reading participates in a form of body-language. I bring the book in and out of itself, riveting it to the realm of the architectural, then extracting it, devouring it as information. I lay it over physical space so as to disrupt their seeming separation, reading and doing… Yet the book reveals to me a secondary text: it speaks toward experimental architecture on some level by performing its own failure, for how can it ever produce or reveal or cast the full promise such experimentation suggests—in this sense, the book is also its own supplement, by being truly excessive (its pages are like a froth spilling over from architectural culture) and at the same time, revealing the very lack of the thing it supplements: itself. Thus, the book never leaves me—I can't get rid of it—and at the same time, I'll always lose it amidst the continual reading it instigates.

"I remember I had it with me yesterday…"

Scott Berzofsky, Nicholas Petr & Nicholas Wisniewski are artists who live, work, and organize in Baltimore.

Dr Kathy Battista is a writer, lecturer and curator, and author of the forthcoming "Women's Work: Feminist Artists in 1970s London" (I B Tauris 2007).

Ken Ehrlich is an artist and writer based in L.A. He is the co-editor of "Surface Tension: Problematics of Site" (Errant Bodies 2003).

e-Xplo is the framework for the collaboration between Erin McGonigle, Heimo Lattner, and Rene Gabri. e-Xplo develops maps, routes, sound and film materials as reflections of a multifaceted investigation into location, context, social identity, landscape, and the public space of information.

Jennifer Gabrys is Lecturer in Design at Goldsmiths College, University of London. She is currently completing her PhD thesis, "The Natural History of Electronics," in Communication Studies at McGill University.

Claudine Isé joined the Wexner Center as associate curator of exhibitions in 2004. She has also worked as an arts writer for the Los Angeles Times and holds a PhD in Film, Literature and Culture from the University of Southern California.

BIOGRAPHIES

Brandon LaBelle is an artist and writer working with the specifics of location. He is the author of "Background Noise" (Continuum 2006) and co-editor of "Surface Tension: Problematics of Site" (Errant Bodies 2003).

Brandon Lattu is a L.A.-based artist. He teaches in the Art Department at the University of Riverside and has exhibited internationally, most recently at Vacio 9, Madrid, Spain.

Goto Newton is an artist living and working in Curitiba, Brazil. He received a Master in Visual Arts at the Fine Arts School of The Federal University of Rio de Janeiro, and in 2004 undertook a degree at CAPES.

Following a fine art degree, **Aoife O'Brien** was awarded a MRes by the London Consortium in 2002. She subsequently worked for *Contemporary* prior to joining Artwise, and continues to write for several publications.

SIMPARCH is an artist collaborative group organized and maintained by Matt Lynch and Steven Badgett. Since 1996, SIMPARCH has been creating large-scale interactive artworks that examine building practices and site specificity.

Robin Wilson works as a critic and curator of art and architecture, and is currently studying for a PhD at the Bartlett, U.C.L.